NORTHUMBERLAND IN PHOTOGRAPHS

NATHAN ATKINSON & SIMON McCABE

AMBERLEY

From Nathan

In January 2019, while out taking sunrise photographs for the book, I witnessed a tragic event. A fisherman named Damian Dixon sadly lost his life when he was taken by the sea. Despite an amazing effort by the coastguard, RNLI, police and ambulance services, it was too late. My thoughts go out to his friends and family, particularly his two friends who witnessed the tragedy. This book is dedicated to Damian.

From Simon

I would like to dedicate my work to my wife Judith and my son Josh, who make me the proudest husband/dad.

First published 2019

Amberley Publishing
The Hill, Stroud
Gloucestershire, GL5 4EP

www.amberley-books.com

Copyright © Nathan Atkinson & Simon McCabe, 2019

The right of Nathan Atkinson & Simon McCabe to be identified as the Authors of this work has been asserted in accordance with the Copyrights, Designs and Patents Act 1988.

ISBN 978 1 4456 8686 8 (print)
ISBN 978 1 4456 8687 5 (ebook)

British Library Cataloguing in Publication Data.
A catalogue record for this book is available from the British Library.

Typesetting by Aura Technology and Software Services, India.
Printed in the UK.

ACKNOWLEDGEMENTS

This work would not be complete without thanking the friendly people of Northumberland for their help and assistance in developing this book. There are many organisations and businesses that spend a good deal of time and effort showing all that Northumberland has to offer. In particular, thank you to those who have given permission to include photographs taken on their land; namely:

Elspeth Gilliland from Ford & Etal Estates for allowing us to include pictures from both villages. Such a beautiful area with lots to see and do.
Hannah Field at Forestry England and Kielder Water and Forest Park for permission to include pictures of the Kielder area.
Jim Walsh at Barter Books, Alnwick. A fantastic place to visit and photograph.
Northumbrian Water for permission to include pictures of Fontburn Reservoir.
National Trust for allowing us to use pictures of Sycamore Gap and Hadrian's Wall.
Steve Newman for sorting a trip to Longstone Lighthouse. Unfortunately, we ran out of time to take up the offer.
College Valley Estates for allowing us to include pictures from the extremely photogenic College Valley.
Reiver Longhorn Beef for permission to take a large number of photos of their fantastic herd of English longhorn cattle.

From Nathan

I'd like to once again thank Sorcha for the number of weekends I have been absent, the evenings I have disappeared, the sleep patterns I have disturbed and all the meal disruptions I have caused. All finished now ... until the next time.

I'd also like to thank John Hill for travelling with me on some of the journeys. I apologise for the climb at Thrunton Woods and the long walk to Riddleham Hope that turned out to be a wasted journey. I hope Shirley wasn't too mad with me.

Thanks to my mum, Peter and Gordon for their support and putting up with endless slideshows of pictures I have taken. I'm thinking of doing a book of photos of my limited plumbing skills just so Gordon can have a laugh.

Thank you to Blake and Ursula for your love and support.

Thanks to Ruth Russell and all the contributors for sorting some much-needed funds after I lost an expensive lens and filter equipment. It was very appreciated. Thanks also to Kev, Lee, Bri, Lucy, Banksy, Scott, Bev, Michelle, Marty, Paul A. and David T. for the various levels of support you offer during the week.

Thanks to Paul Moore for his humour and interest in all that I do. Not sure how you escaped coming with me on any of my trips. Maybe next time.

Thanks to David and Marie Bond, again for your help and support, particularly in my early days. I always feel at home when I come to see you both.

Further acknowledgements to Esther Bamberger, who put me on the spot at the Angel of the North; Paxton's Fish & Chip Shop, who wouldn't realise it but made my day after a long shoot without stopping for any breakfast or lunch; similarly, Pilgrims Coffee House for a much-needed breakfast after an early start to Holy Island and Lindisfarne Mead so I could stock up on supplies; my neighbours for putting up with any clattering noises from arriving/leaving in the middle of the night; Martin Steele for helping me out when I lost all my filter equipment; Nikon UK for attempting to fix my broken lens; and Nick Grant and Jenny Stephens at Amberley Publishing.

From Simon

Thank you to all the photography groups and professional photographers who, over the years, spent time in sharing their valuable tips and experience with a new photographer.

I would also like to give a special thanks to Nathan for inviting me to join him in the creation of this publication. Also, for updating the lengthy shoot list spreadsheet and sharing his vast knowledge and experience in where we can and where we cannot photograph.

ABOUT THE PHOTOGRAPHERS

Nathan Atkinson

Nathan Atkinson is a freelance photographer based in County Durham. Nathan has been interested in photography for over twenty years, initially focussing on landscapes in the north of England through his interest in the outdoors.

Nathan currently has photographs adorning the covers of two Ordnance Survey maps for Middlesbrough and Hartlepool, Stockton-on-Tees and Redcar (OS Explorer Paper Map) (306) and Middlesbrough, Darlington & Hartlepool (OS Landranger Map) (93). He has also published *County Durham in Photographs* with Amberley Publishing.

Website: www.miura-photography.co.uk
Facebook: @miuraphotography
Instagram: miuraphotography
Twitter: @Nathan_Lakes
Email: nathan@miura-photography.co.uk

Simon McCabe

Simon McCabe is a Teesside-based photographer whose photography journey started over fifteen years ago. A close family member who was unable to travel anymore said, 'Travel the world and take as many photos as you can, so I can see and experience the world through your eyes.' Since then, his experience, style and passion has been evolving and with each new challenge he has learnt new techniques in photography and editing.

Nature, landscape and wedding photography are his main fields of experience.

Which of my photographs is my favorite? The one I'm going to take tomorrow.

Imogen Cunningham

Facebook: SimonMcCabePhotography
Instagram: Simonmccabe5
Email: Simon.mccabe2@gmail.com

INTRODUCTION

When most people think of Northumberland, they think of the gorgeous coastline and long stretches of clean sandy beaches. Northumberland offers so much more and through the course of compiling this book, it has opened our eyes to the wide variety of fantastic locations the county has to offer.

Producing photographs for this book has been an epic journey involving a huge amount of time planning routes, watching multiple weather forecasts, tide times and cloud cover. We have lost equipment, turned up at locations that were demolished, arrived in the early hours of the morning to have the timing wrong and revisited the same location multiple times to get the shot just right. It has been enjoyable and very interesting.

Starting off with a relatively small location list, this quickly expanded through the help of social media groups and local knowledge. There are some well-known places and attractions we haven't been able to include. This is due to both running out of time and the strict rules certain locations have on commercial photography.

We feel exceptionally proud to be from the North East after the help and friendliness we have received from the Northumbrians.

We hope you enjoy the book.

More information on some of the locations we have photographed can be accessed via the links below:

Northumberland National Park: www.northumberlandnationalpark.org.uk
Northumberland Coast AONB: www.northumberlandcoastaonb.org
Northumberland Tourism: www.northumberlandtourism.org.uk
College Valley Estates: www.college-valley.co.uk
Ford & Etal Estates: www.ford-and-etal.co.uk
Kielder Water and Forest Park: www.visitkielder.com
Barter Books: www.barterbooks.co.uk
Reiver Longhorn Beef: www.reiverlonghorn.com
Northumbrian Water: www.nwl.co.uk/your-home/leisure.aspx
National Trust: www.nationaltrust.org.uk

BY THE COAST

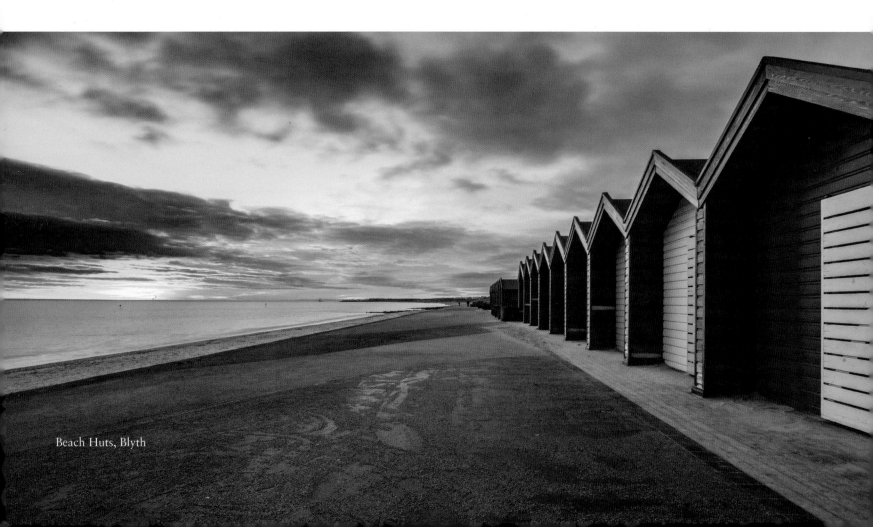

Beach Huts, Blyth

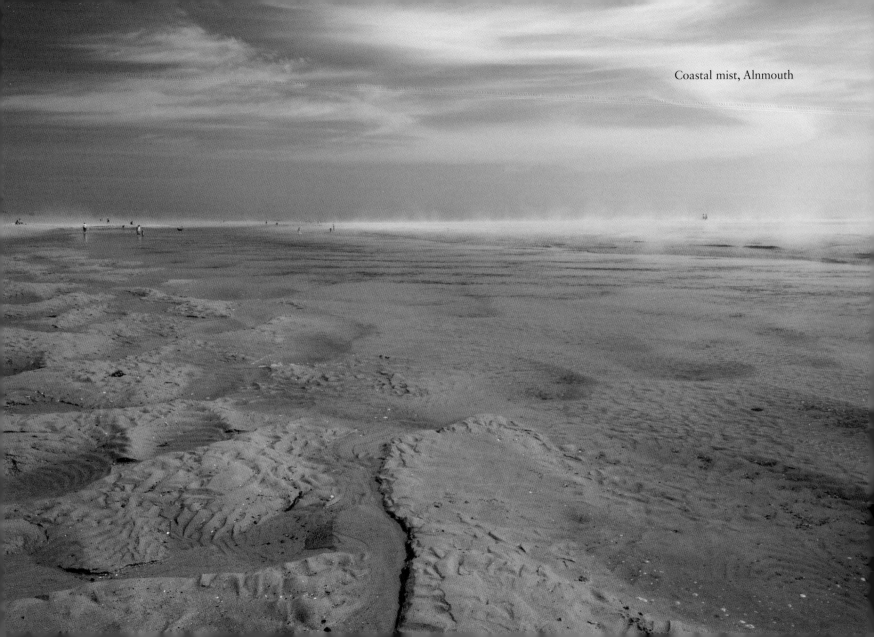

Coastal mist, Alnmouth

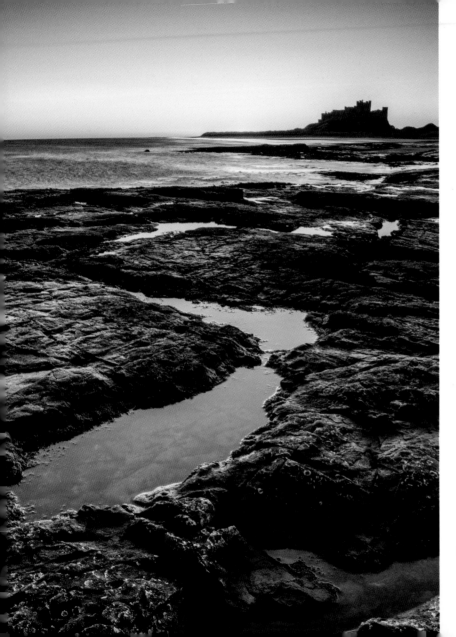

Bamburgh Castle

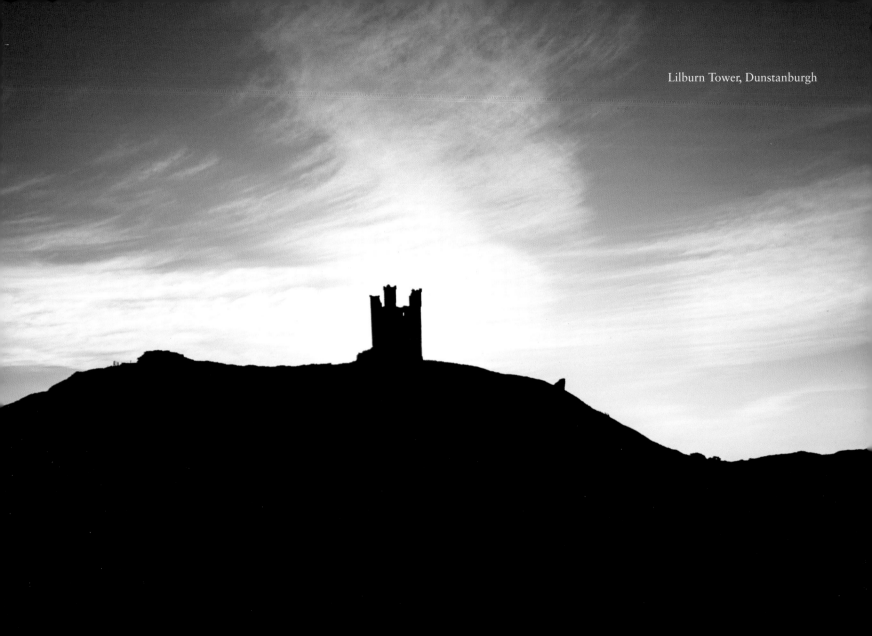
Lilburn Tower, Dunstanburgh

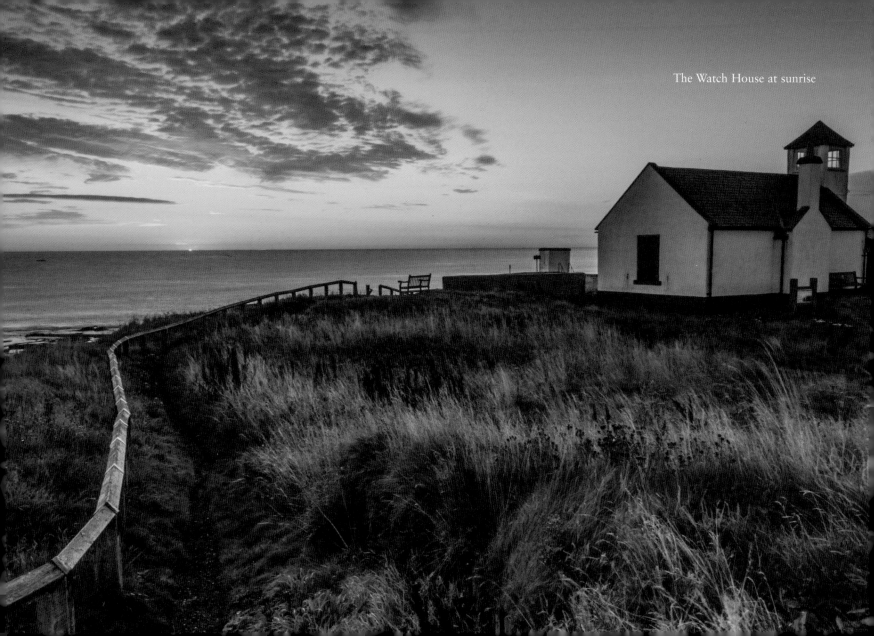

The Watch House at sunrise

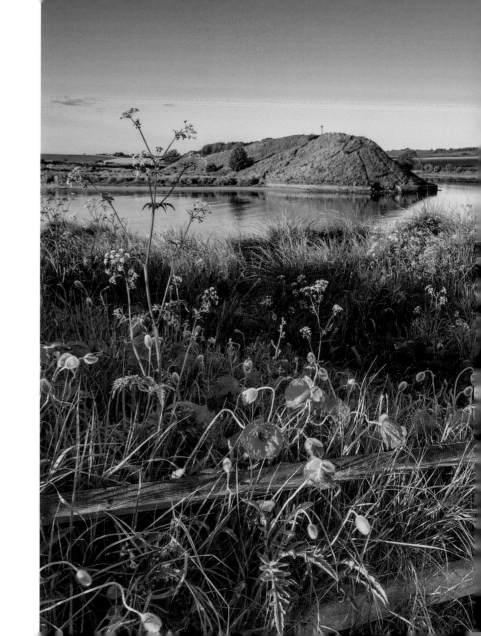

Alnmouth poppies

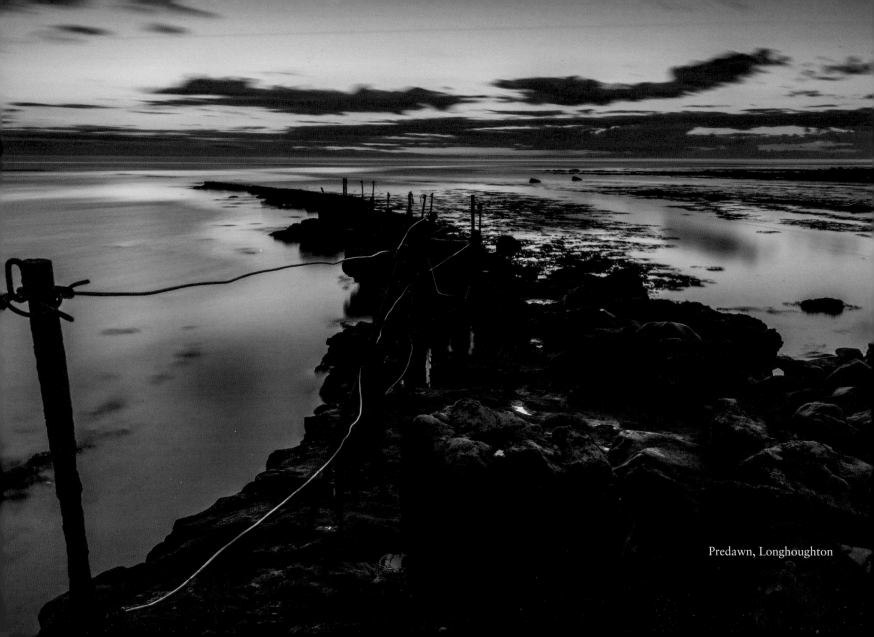

Predawn, Longhoughton

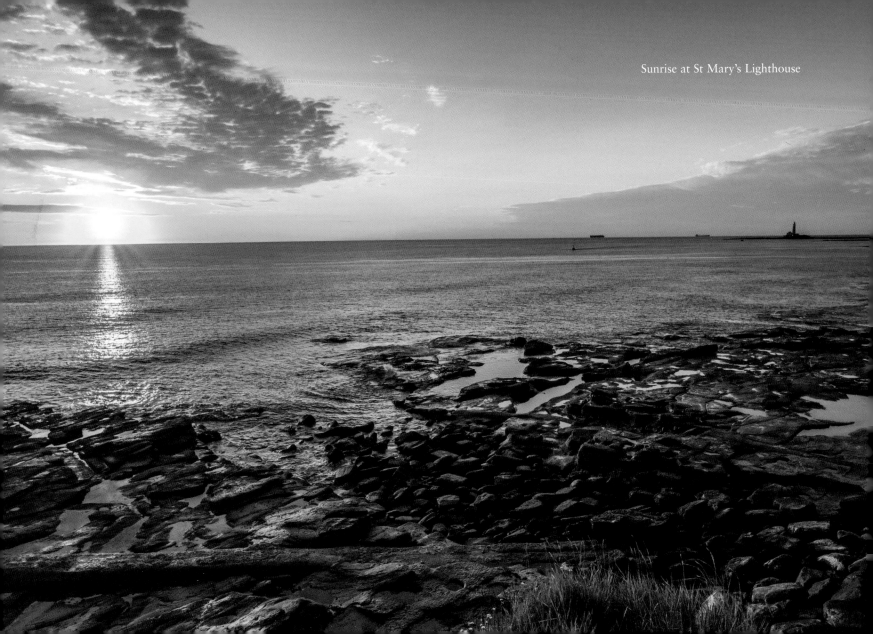

Sunrise at St Mary's Lighthouse

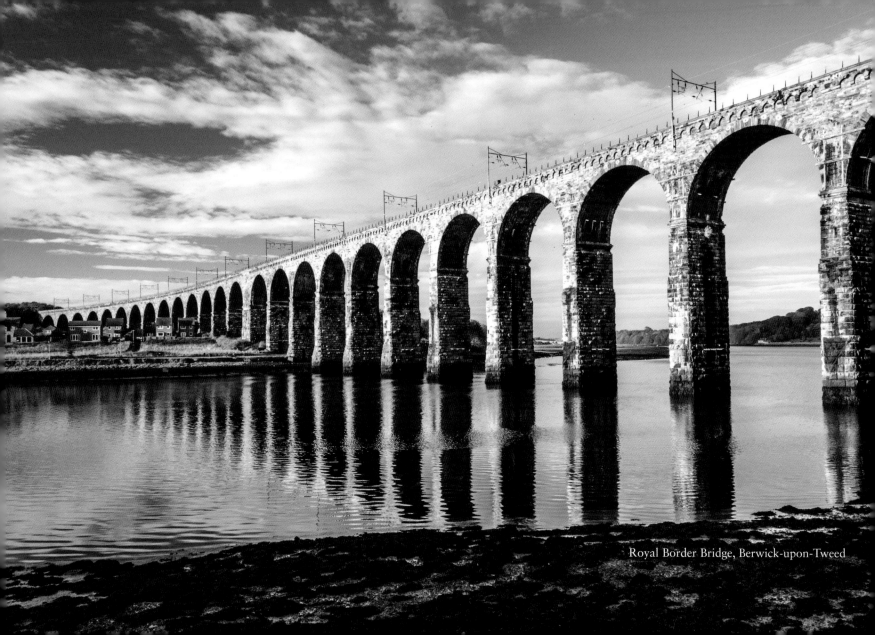

Royal Border Bridge, Berwick-upon-Tweed

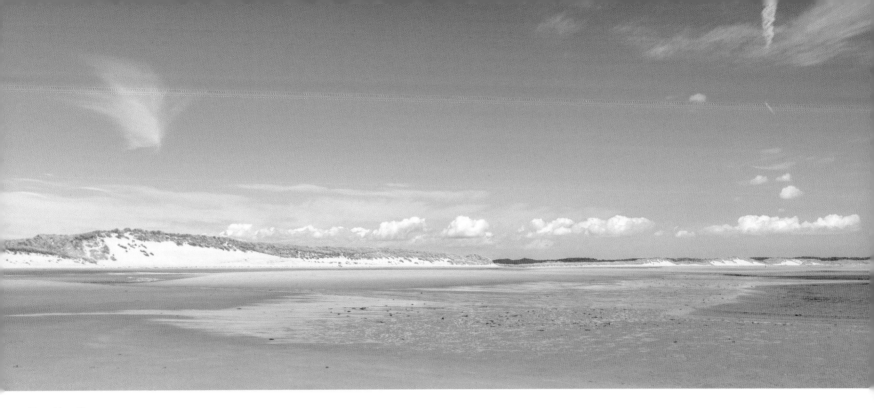

Druridge Bay

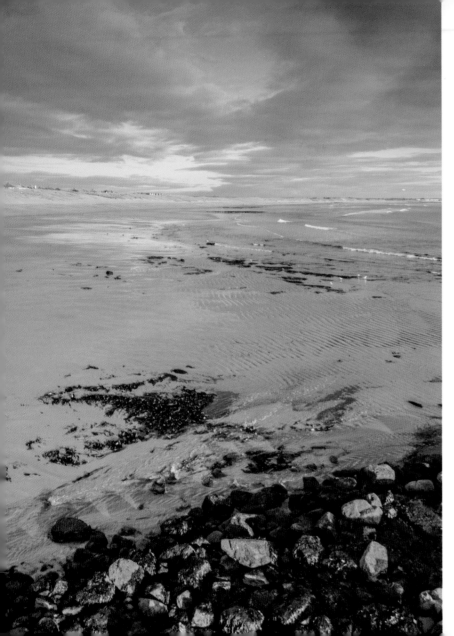

Hartley Links

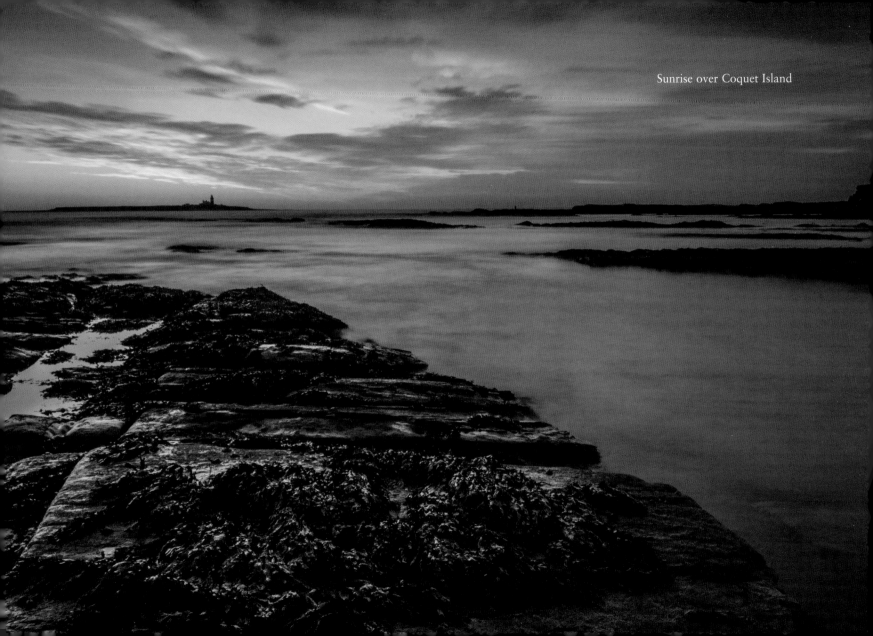

Sunrise over Coquet Island

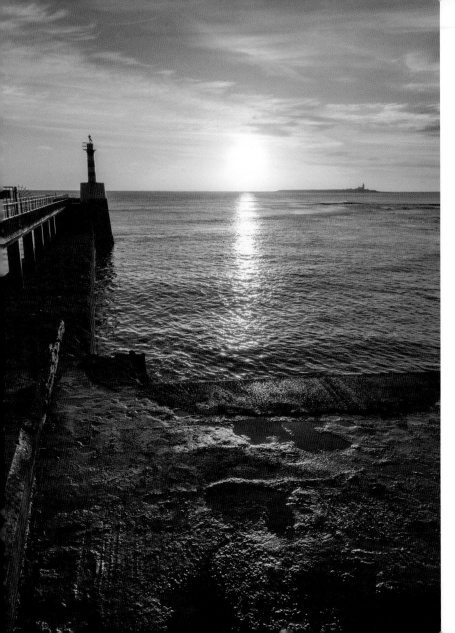

Amble Pier

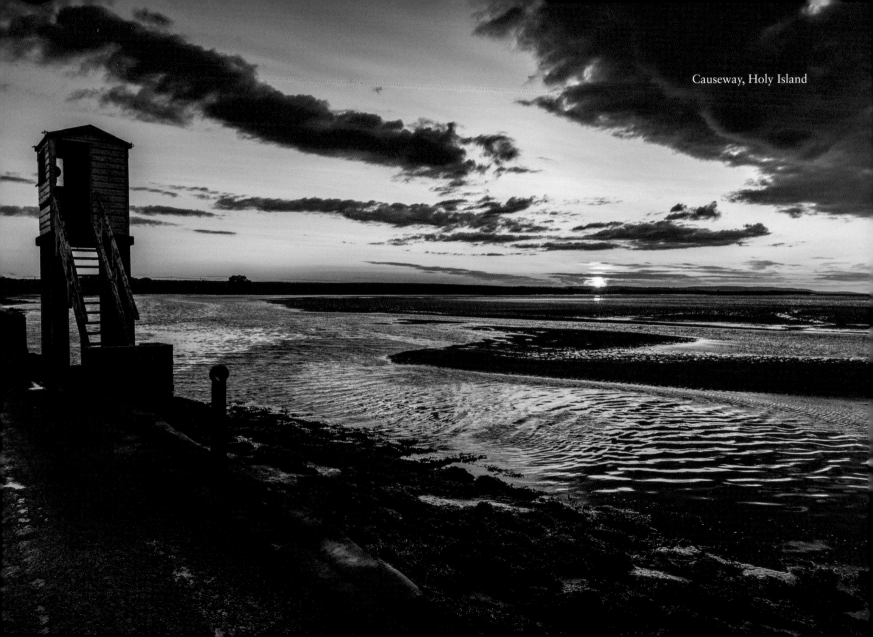

Causeway, Holy Island

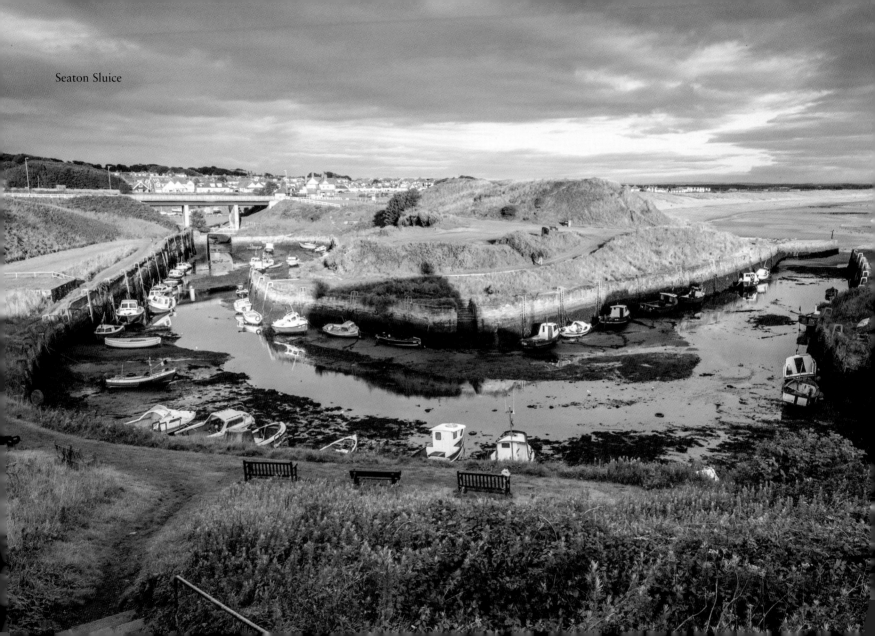

Seaton Sluice

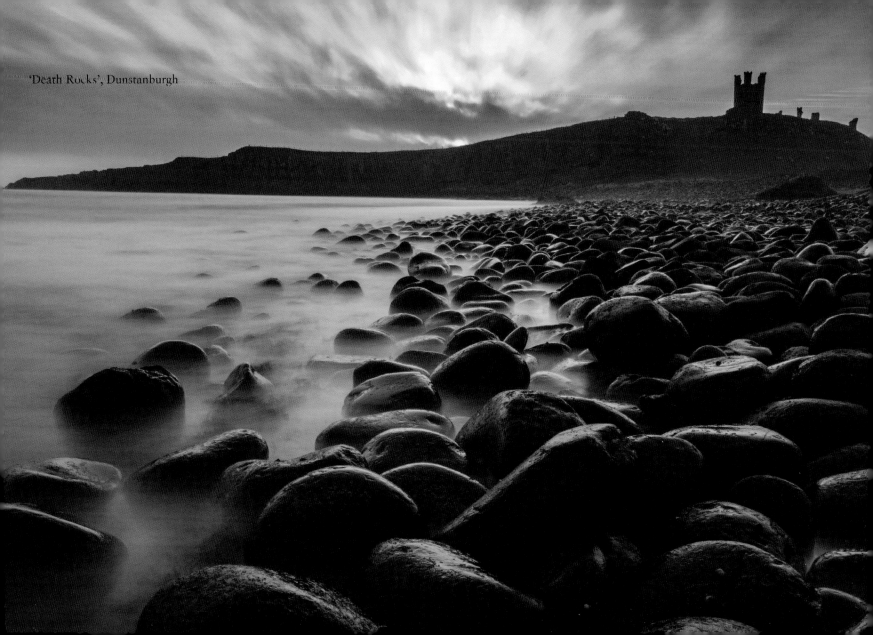

'Death Rocks', Dunstanburgh

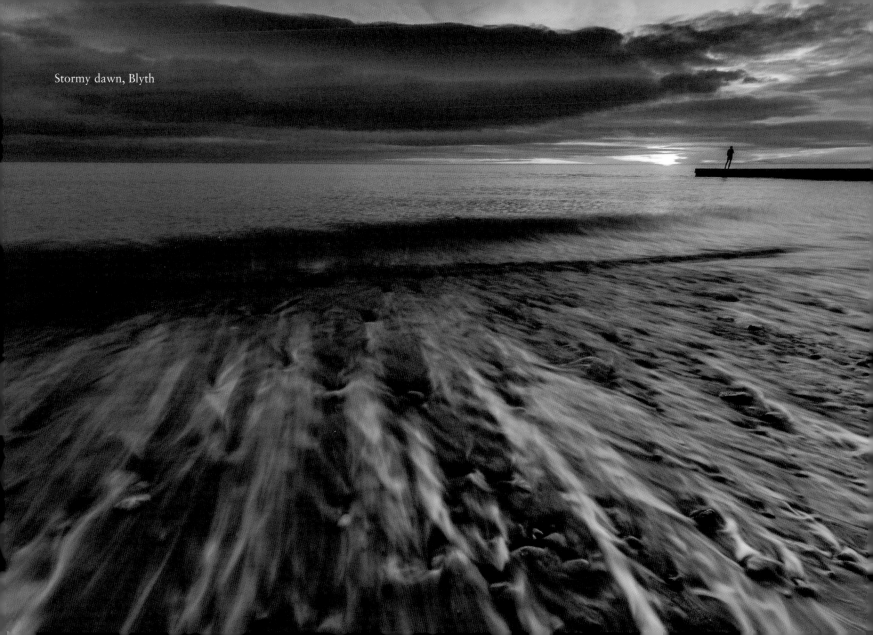
Stormy dawn, Blyth

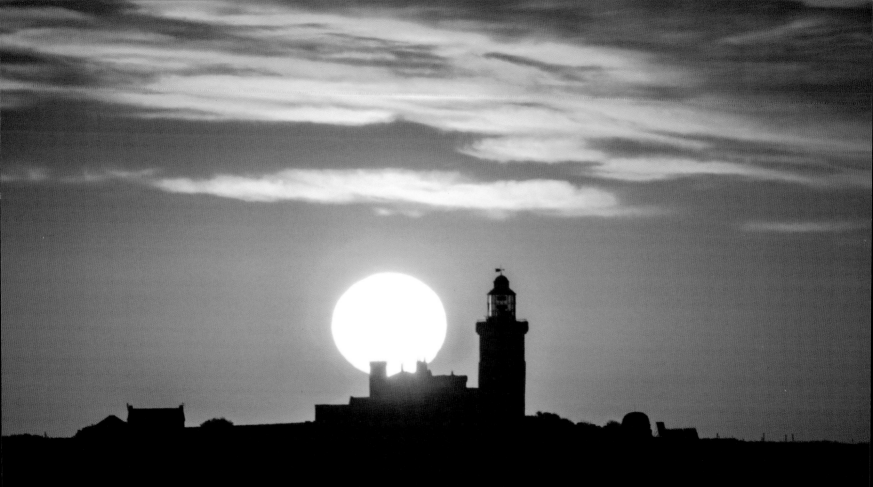

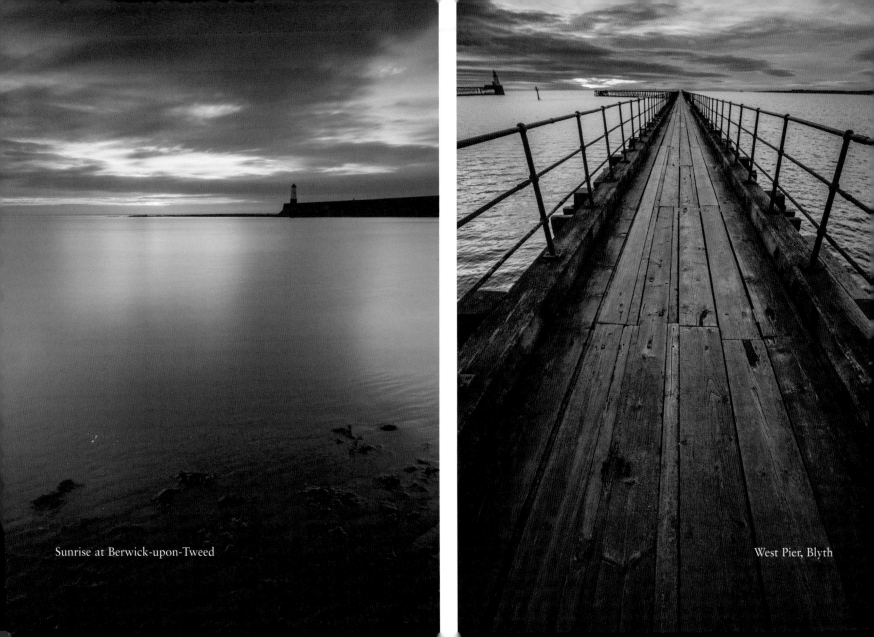

Sunrise at Berwick-upon-Tweed

West Pier, Blyth

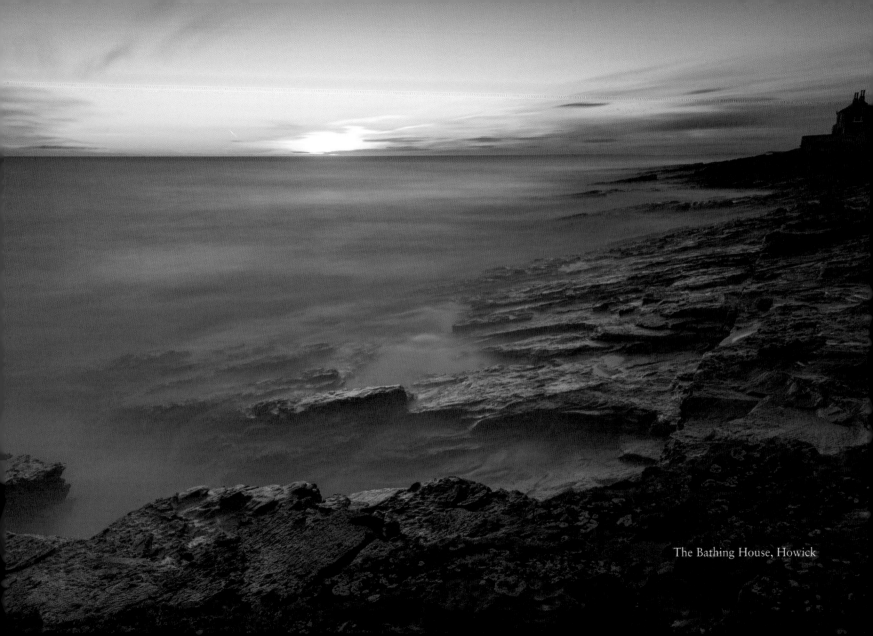

The Bathing House, Howick

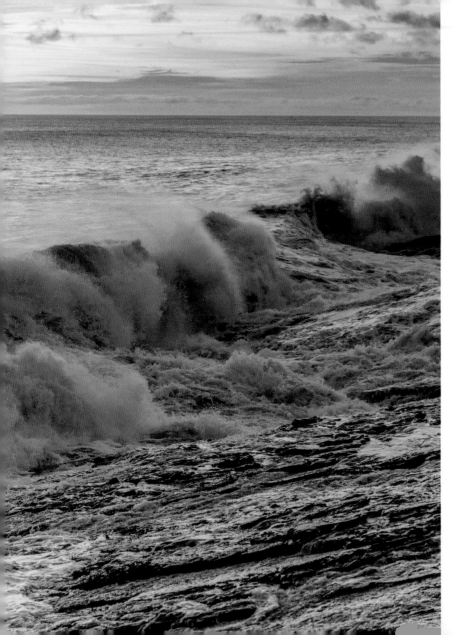

White horses

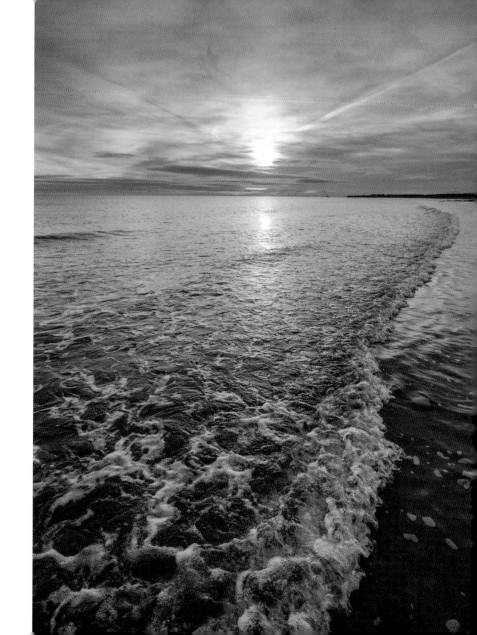

Gentle waves, Blyth

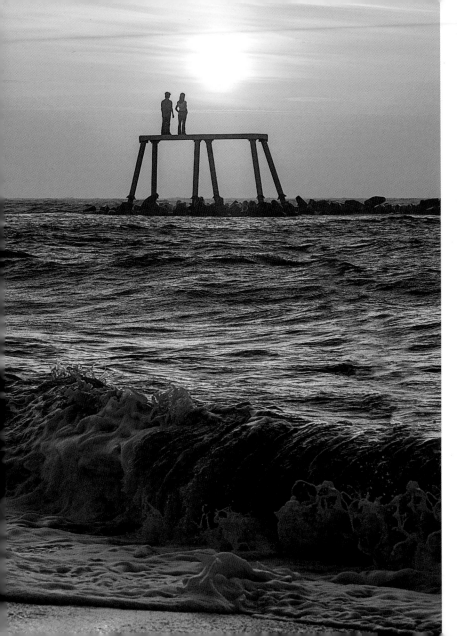

The Couple, Newbiggin-by-the-Sea

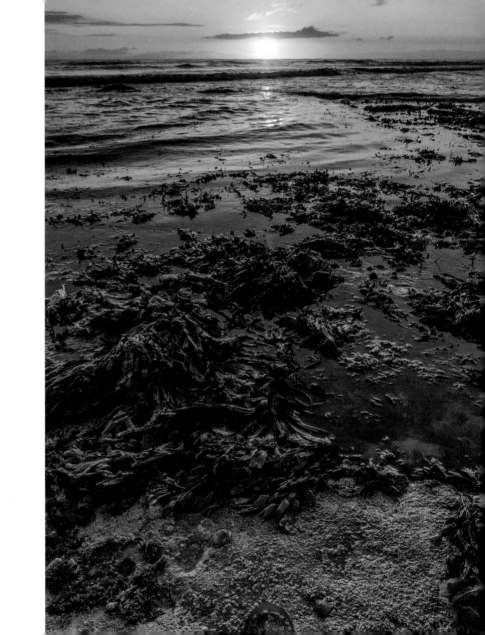

Sunrise at Boulmer

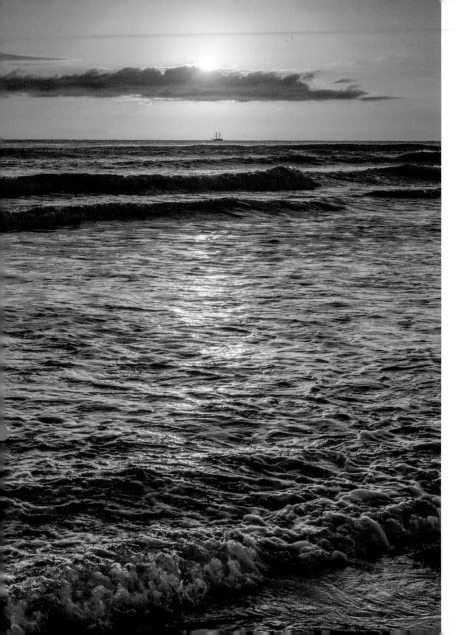

Williams II tallship at sunrise

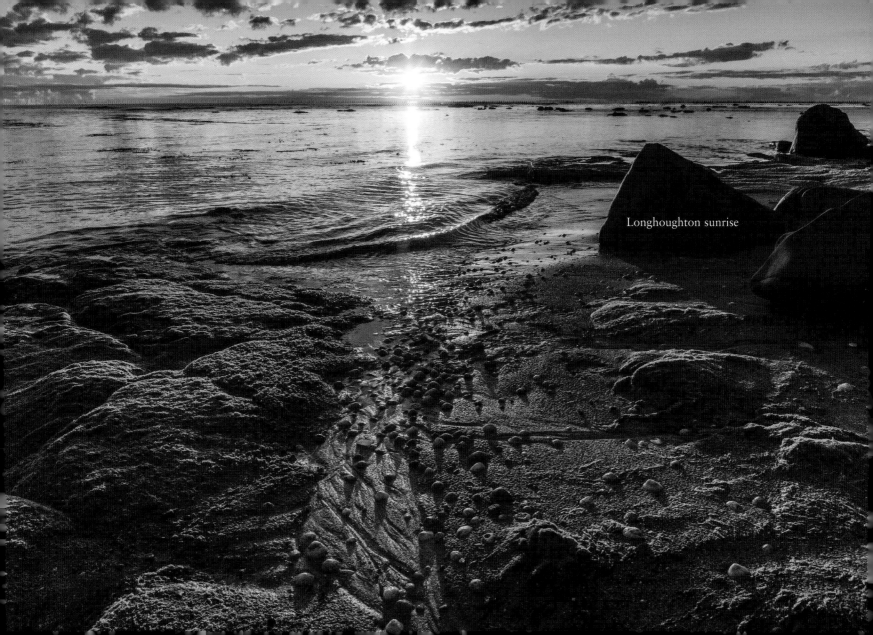

Longhoughton sunrise

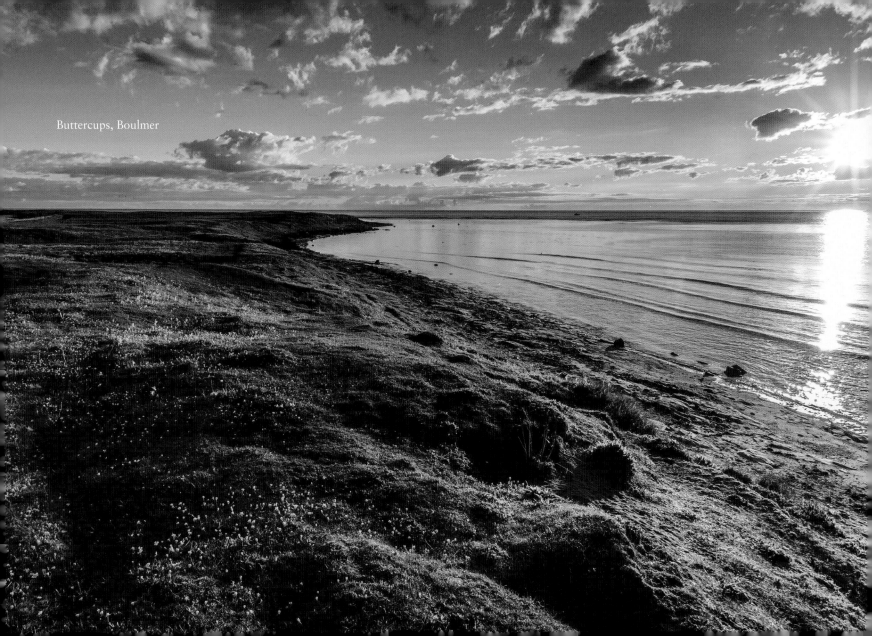
Buttercups, Boulmer

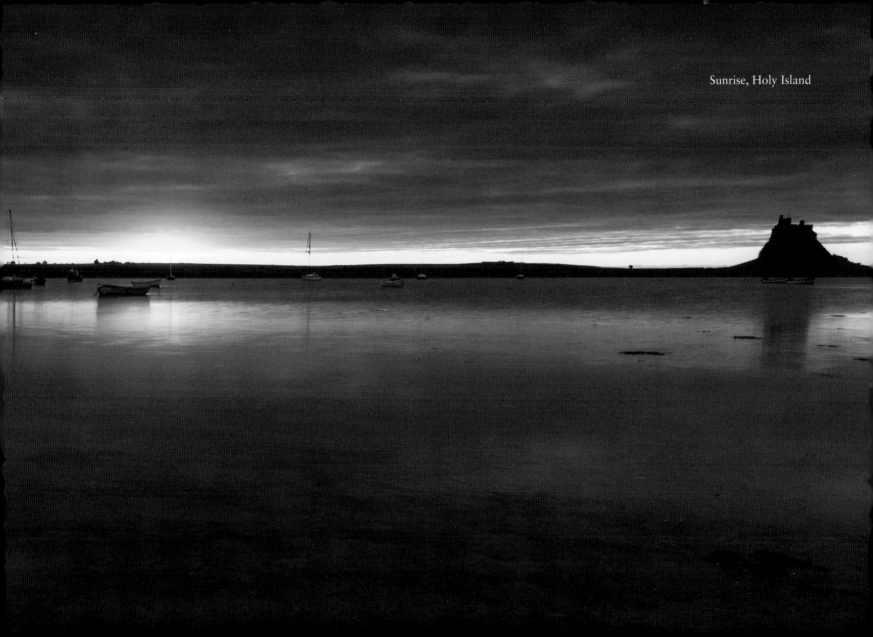
Sunrise, Holy Island

AT NIGHT

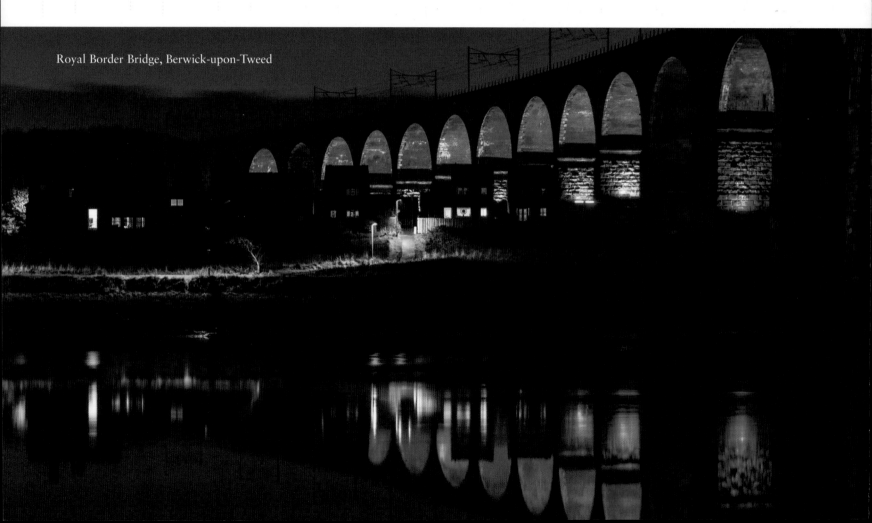

Royal Border Bridge, Berwick-upon-Tweed

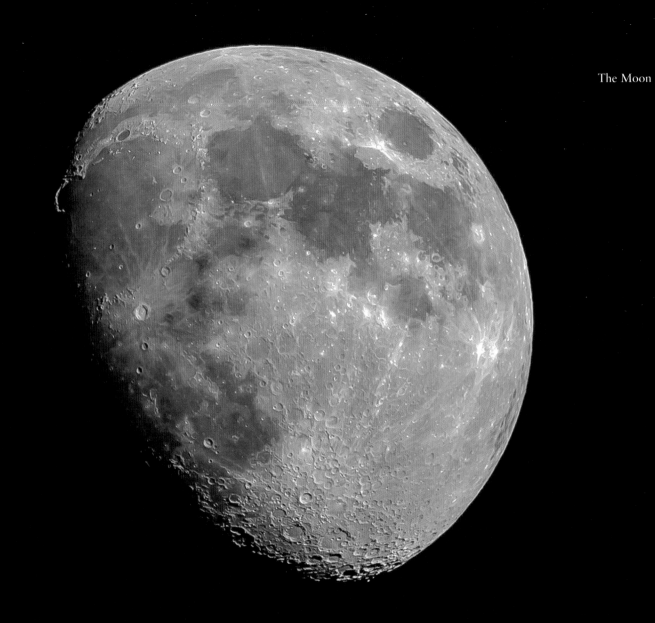

The Moon

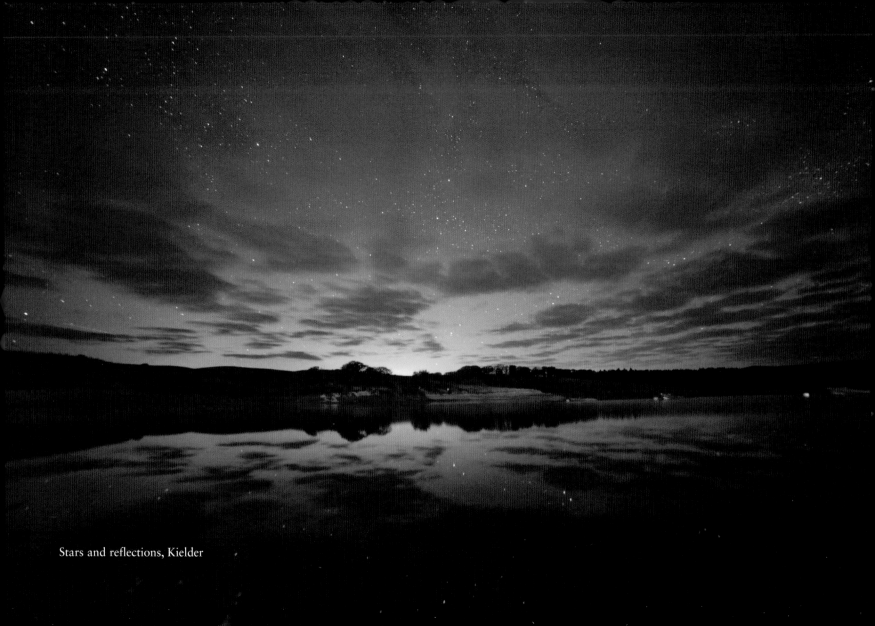

Stars and reflections, Kielder

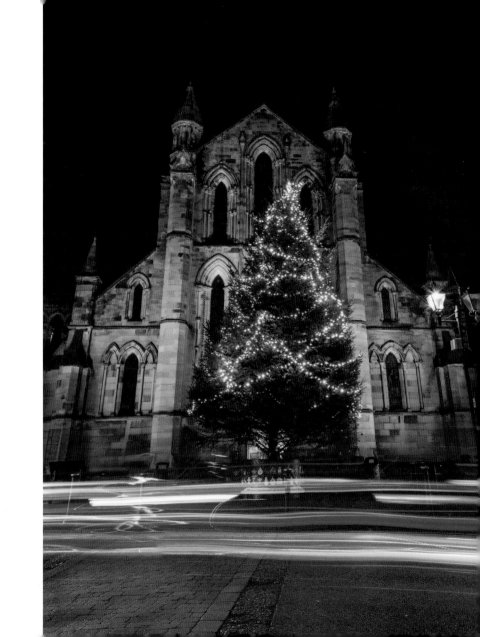

Christmas in Hexham

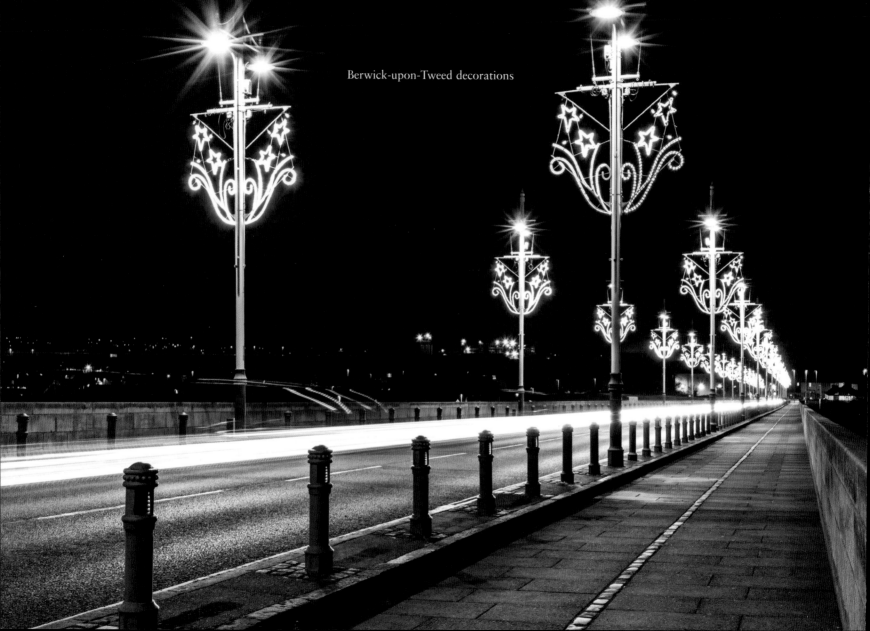

Berwick-upon-Tweed decorations

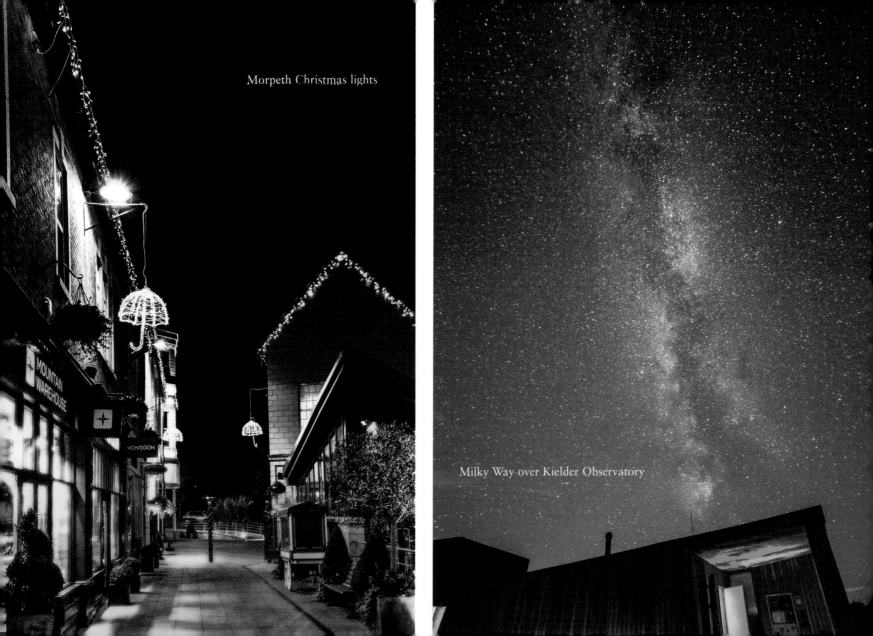

Morpeth Christmas lights

Milky Way over Kielder Observatory

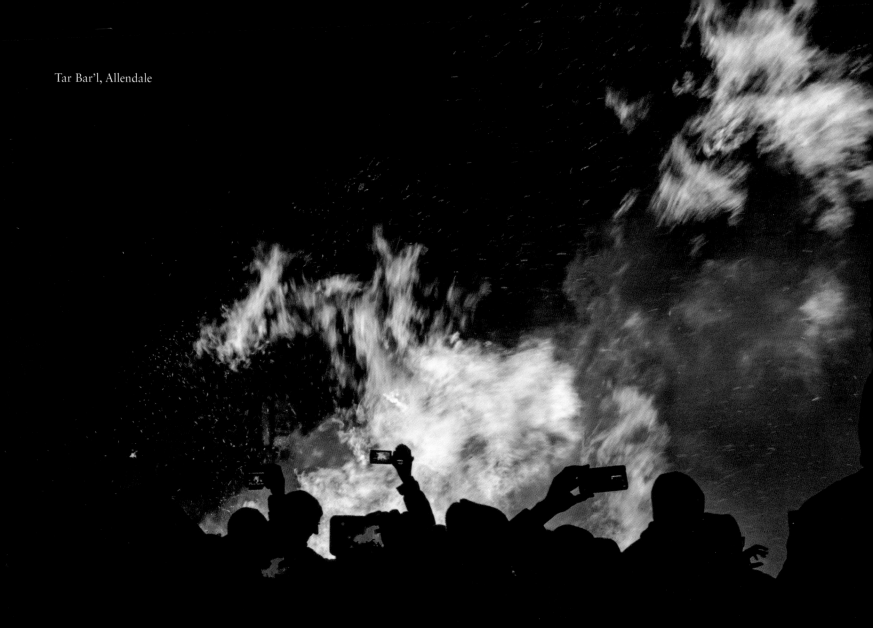

Tar Bar'l, Allendale

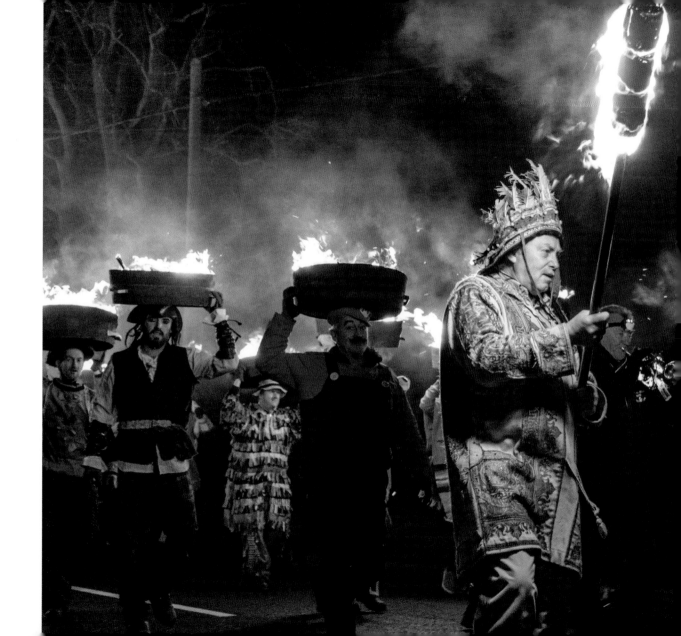

Tar Bar'l, Allendale

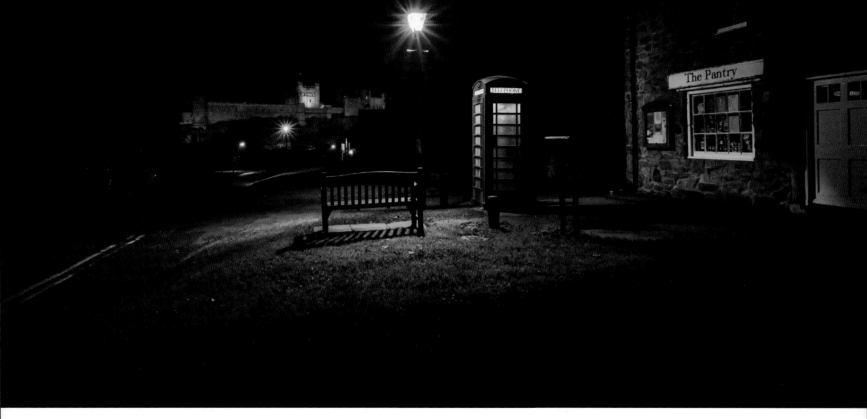

After the tourists have gone, Bamburgh

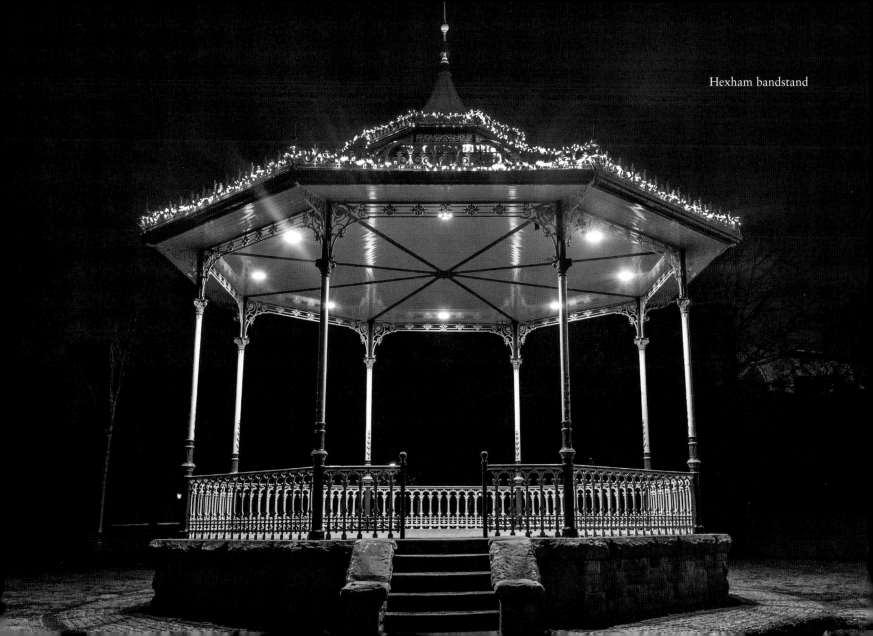

Hexham bandstand

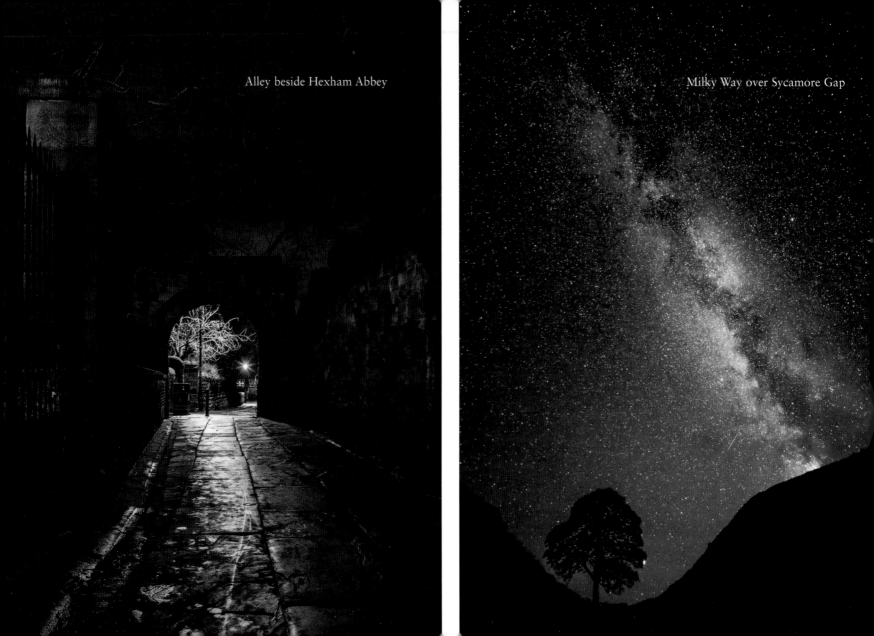

Alley beside Hexham Abbey

Milky Way over Sycamore Gap

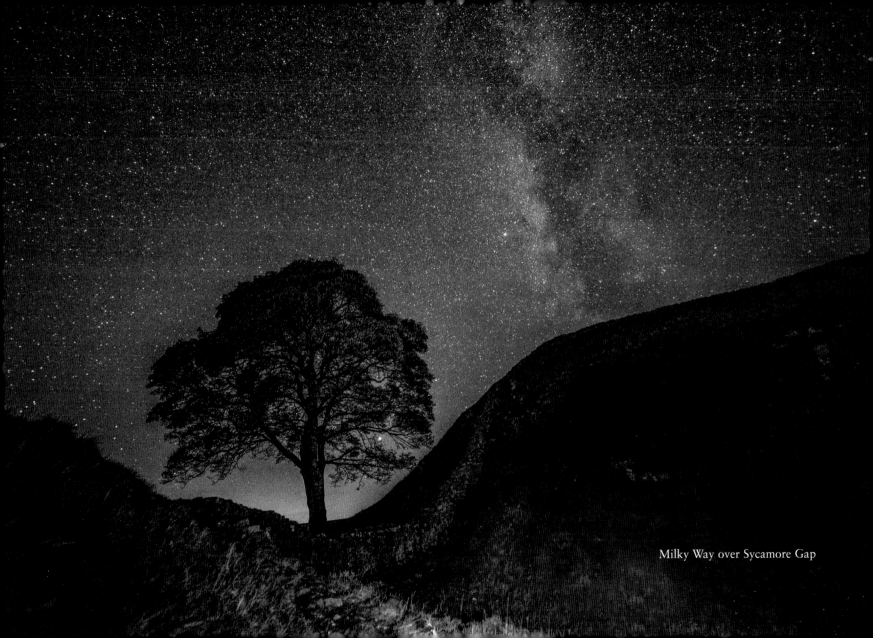

Milky Way over Sycamore Gap

IN THE COUNTRY

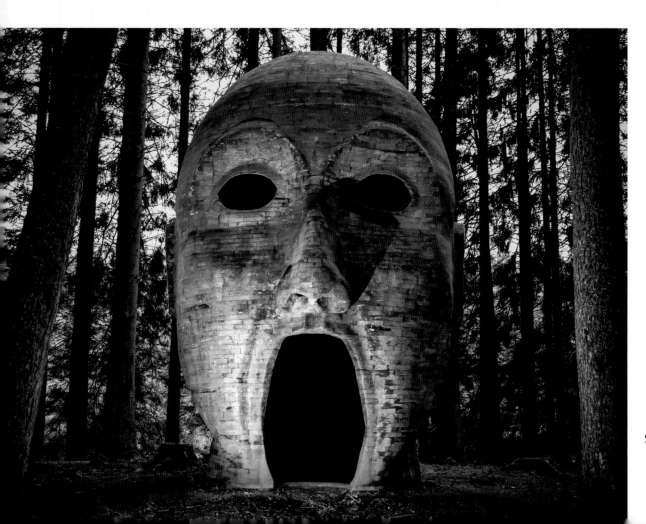

Silvas Capitalis, Kielder

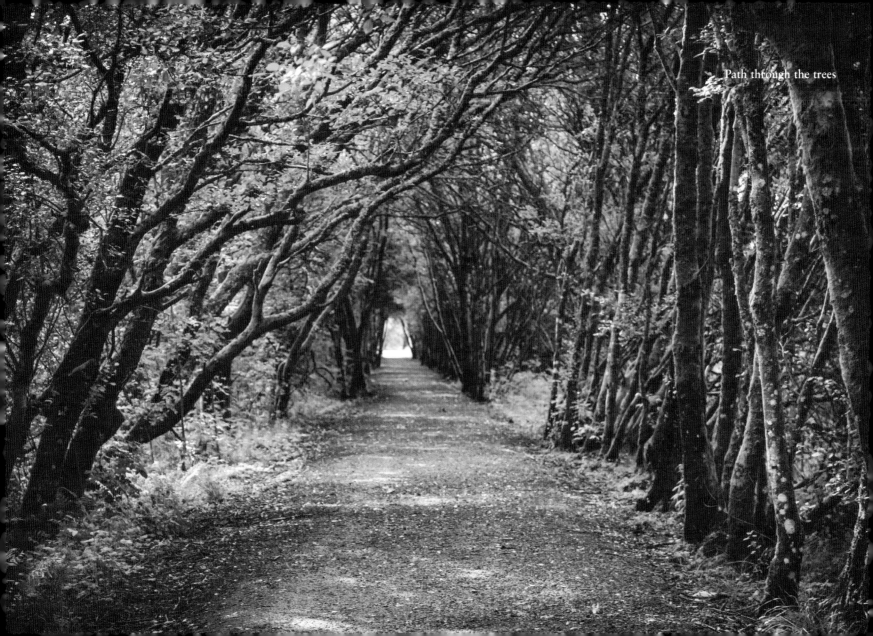

Path through the trees

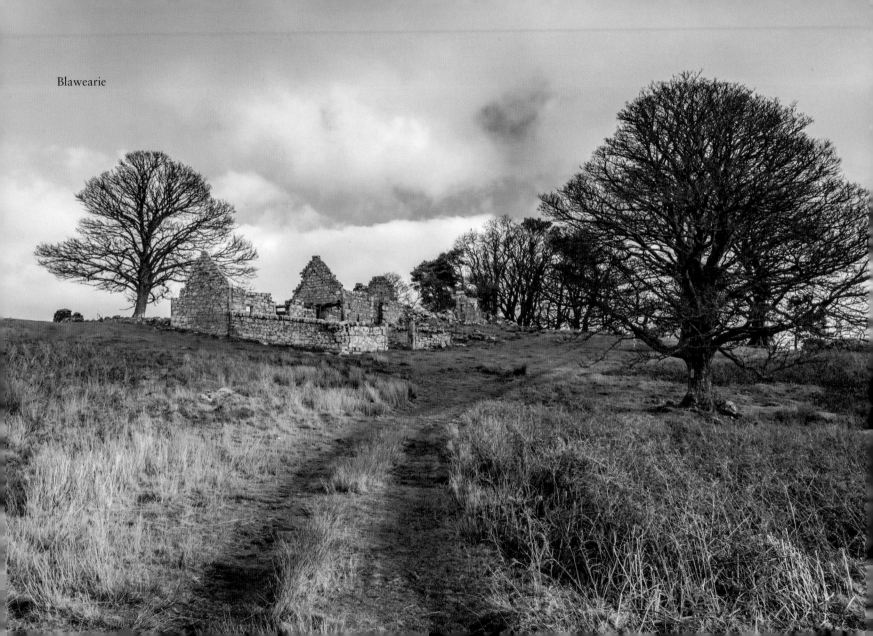

Blawearie

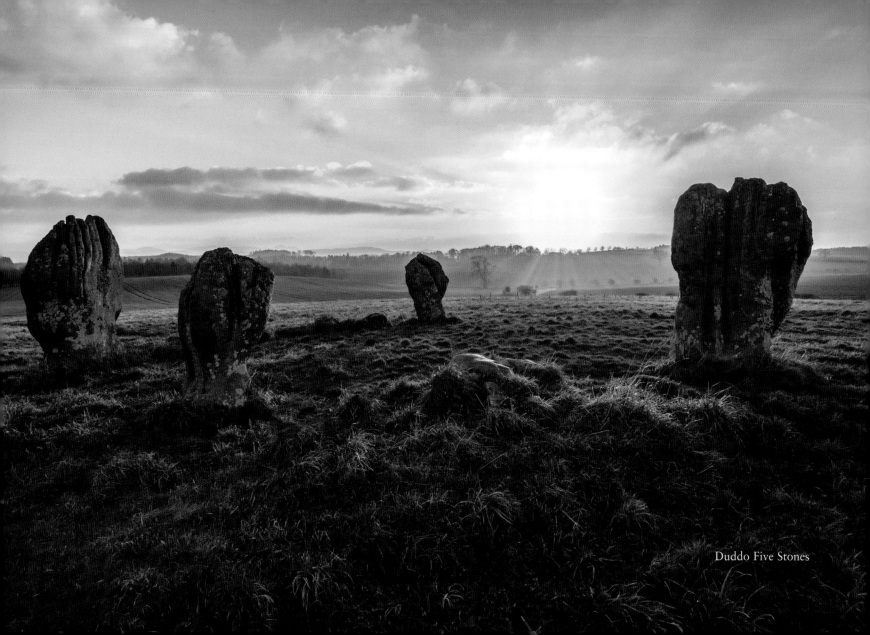

Duddo Five Stones

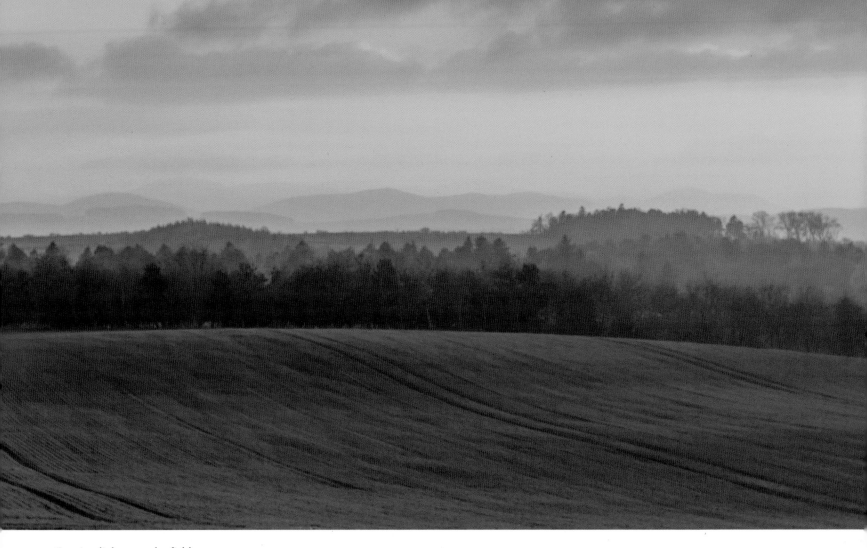

Evening light over the fields

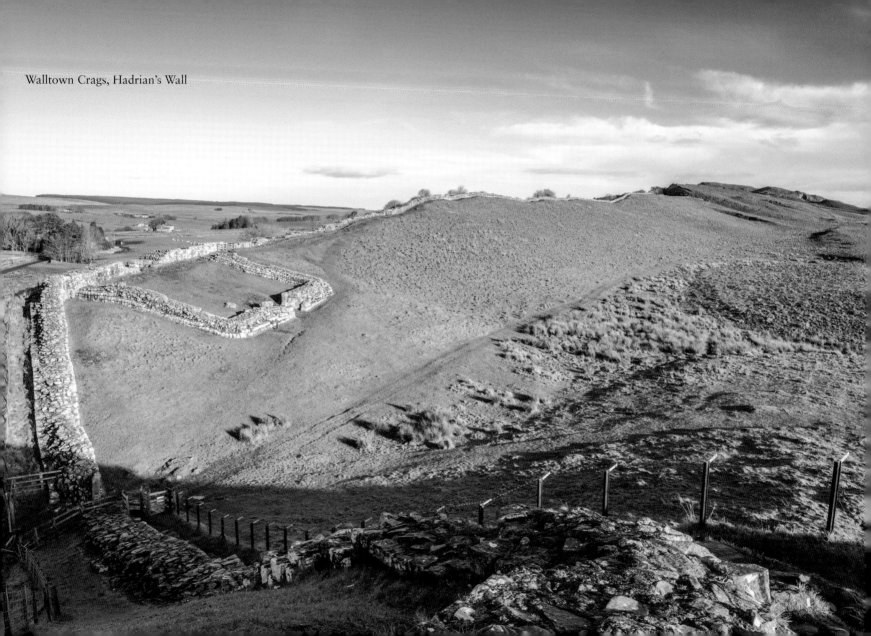

Walltown Crags, Hadrian's Wall

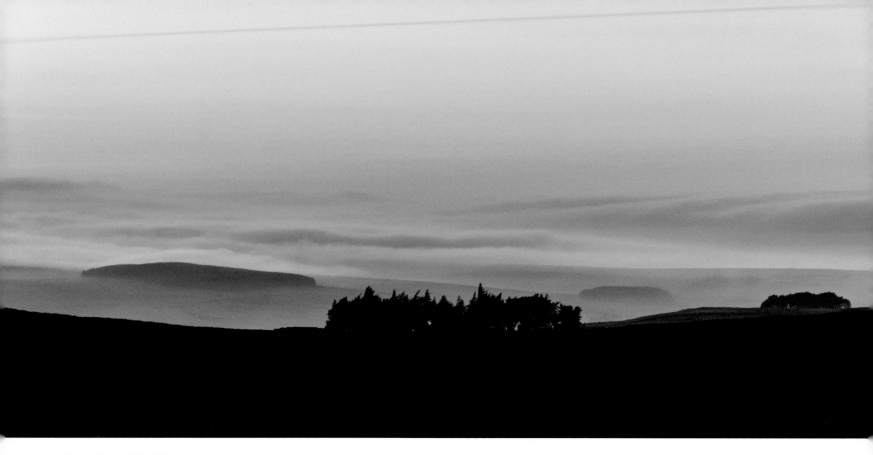

Mist rolls in, Allendale

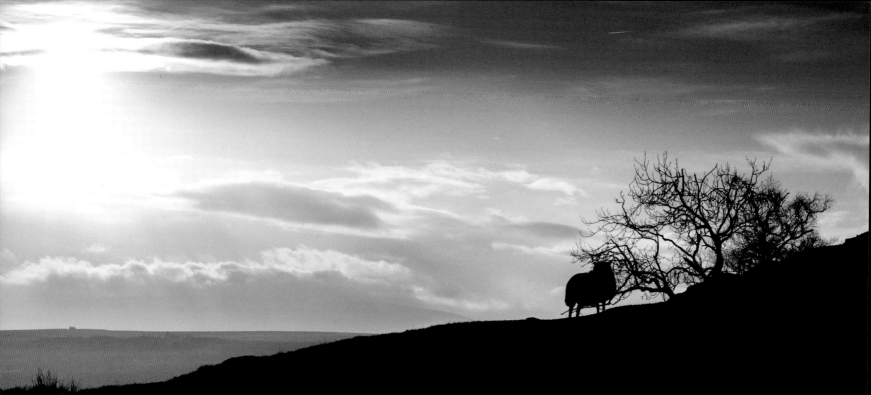

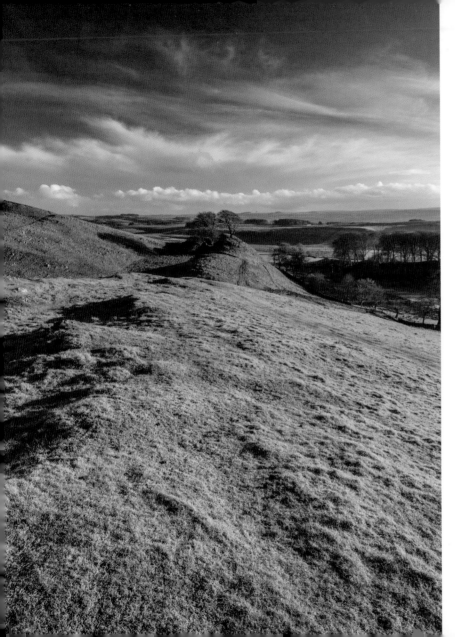

View towards Haltwhistle

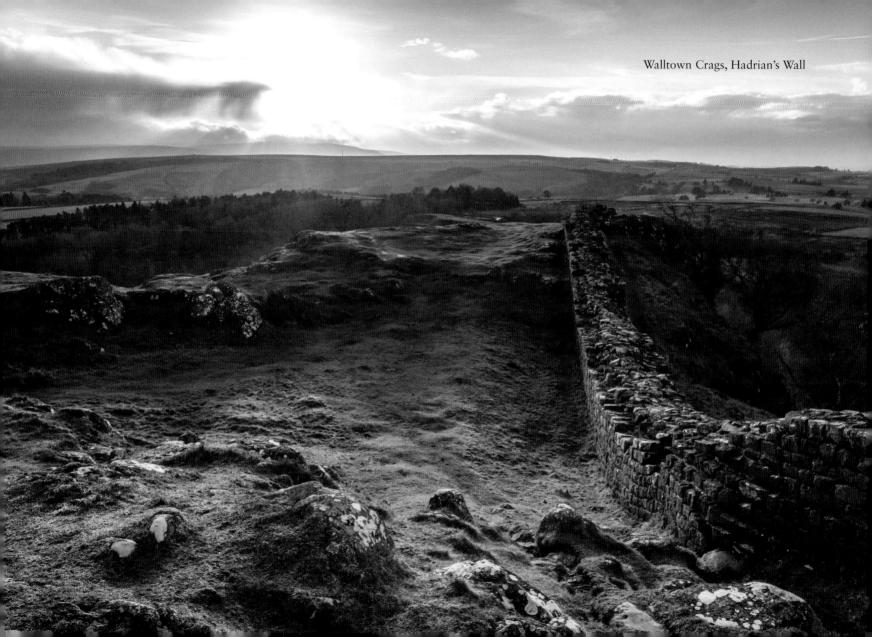
Walltown Crags, Hadrian's Wall

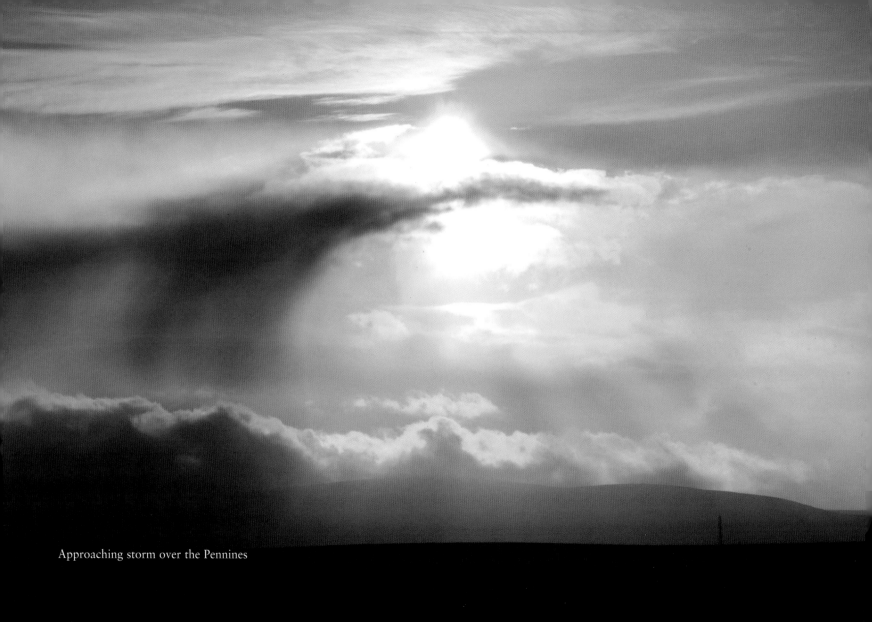

Approaching storm over the Pennines

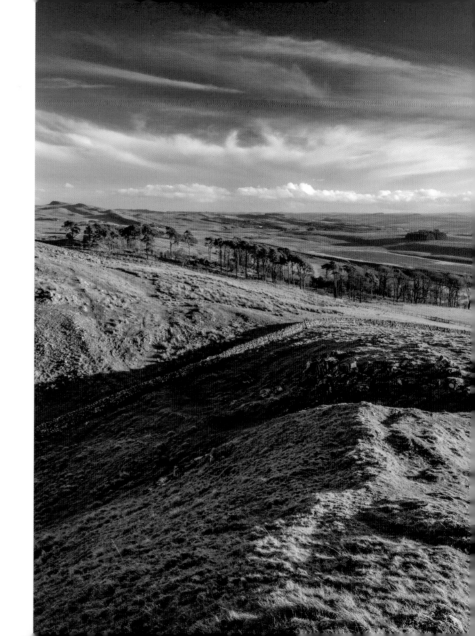

Treeline near Hadrian's Wall

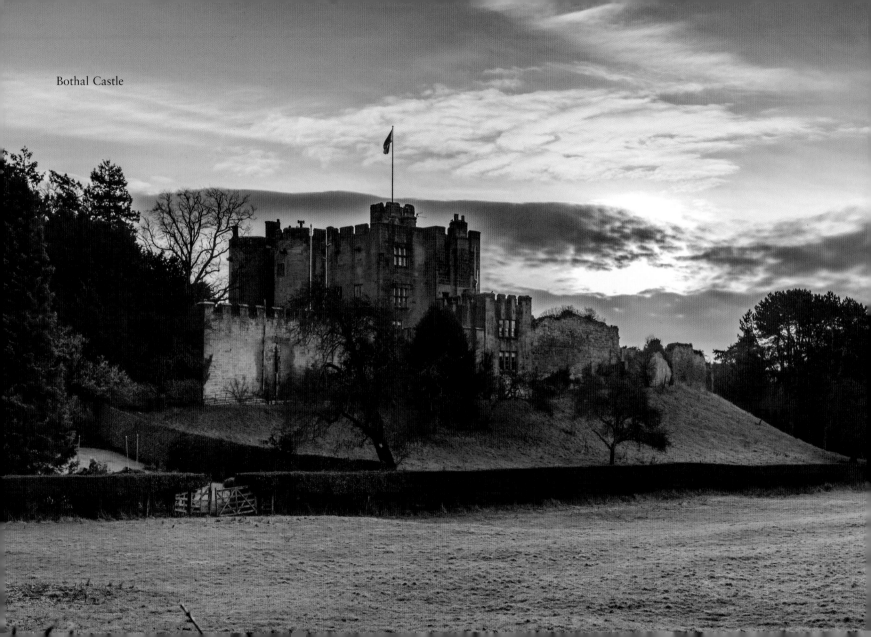

Bothal Castle

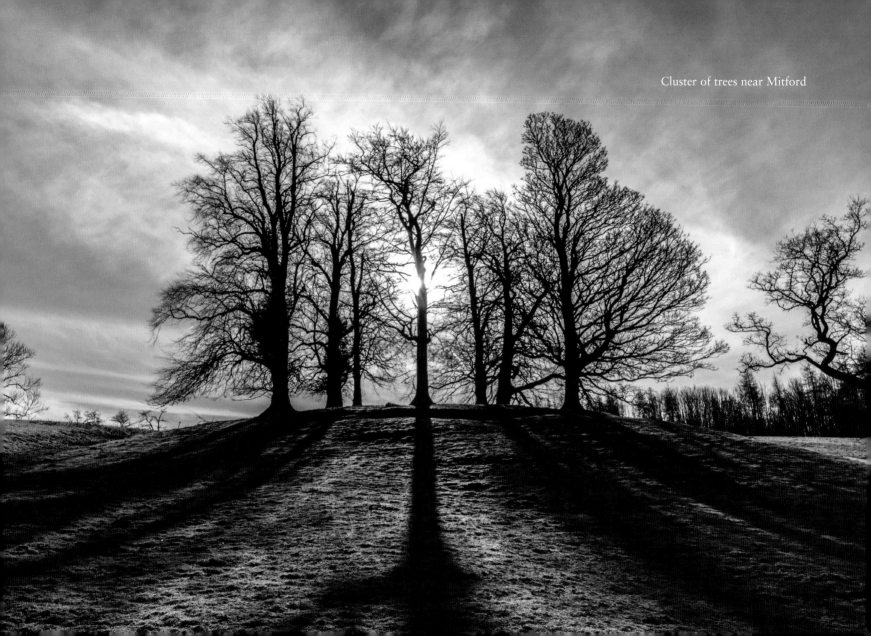

Cluster of trees near Mitford

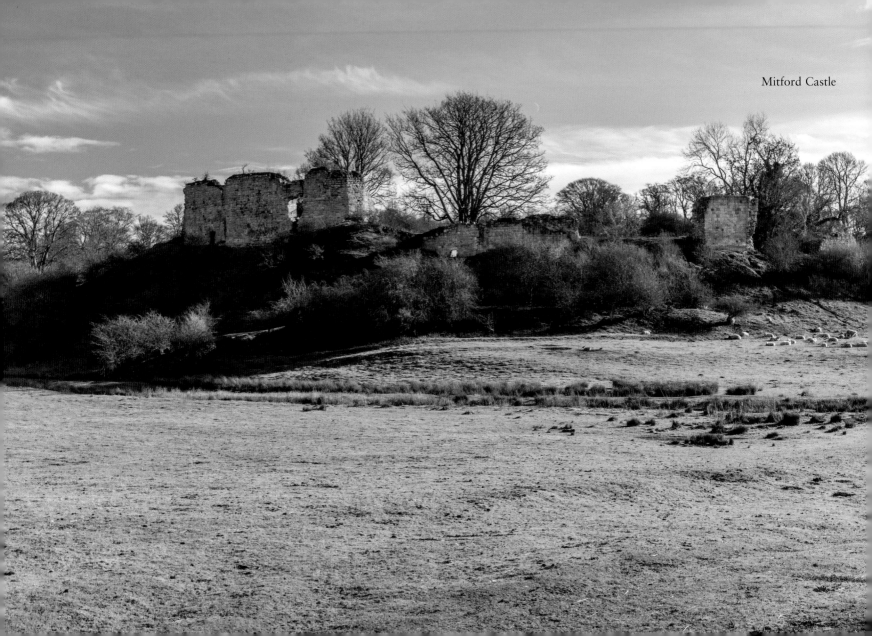

Mitford Castle

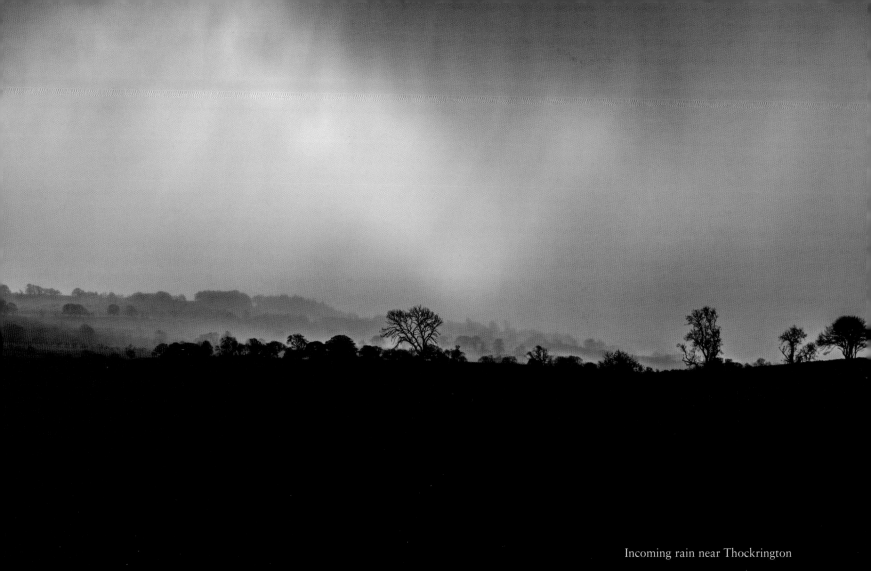

Incoming rain near Thockrington

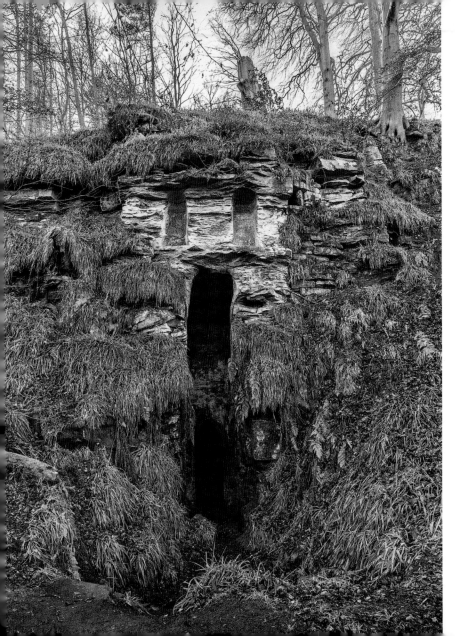

Hartburn Grotto

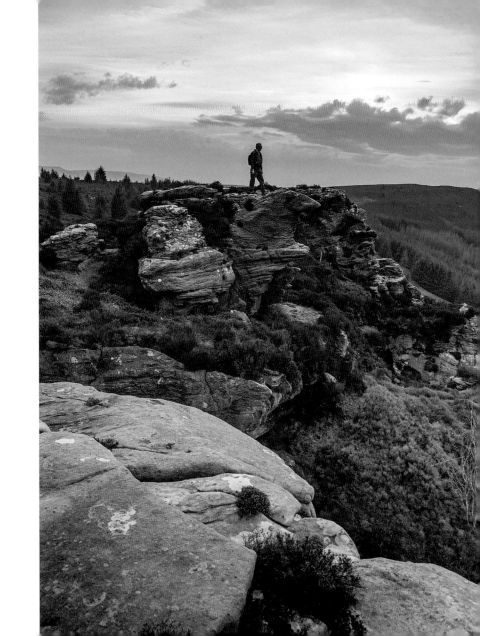

Coe Crags, Thrunton

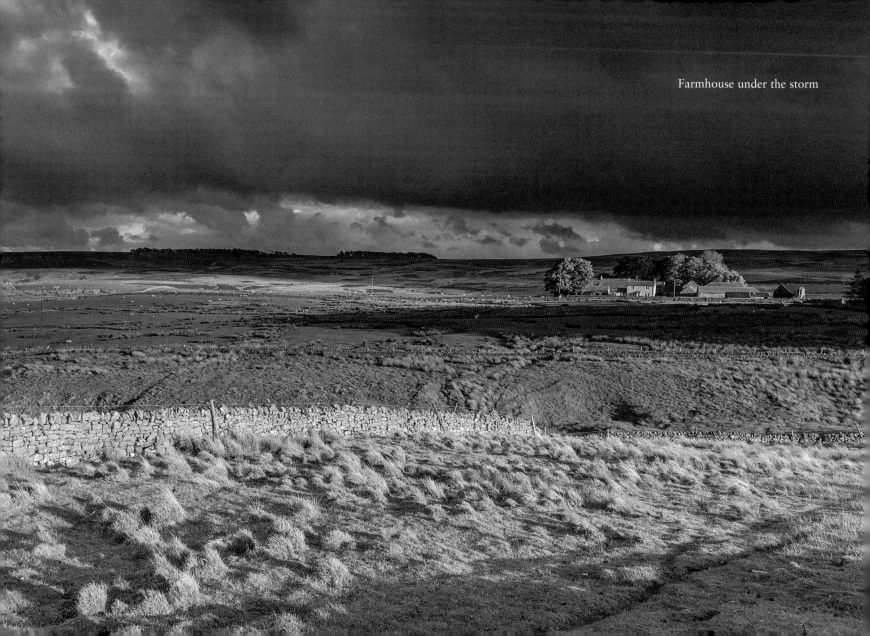

Farmhouse under the storm

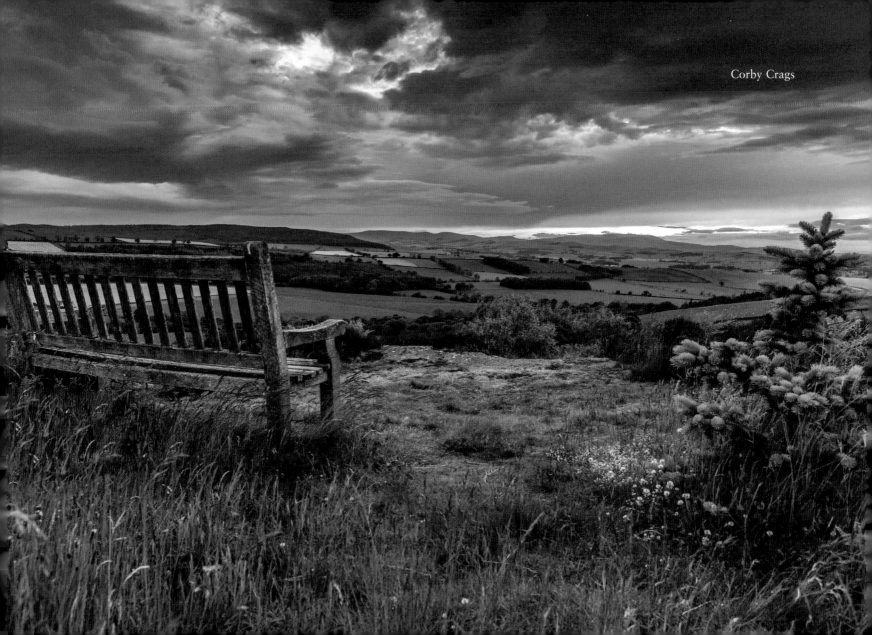

Corby Crags

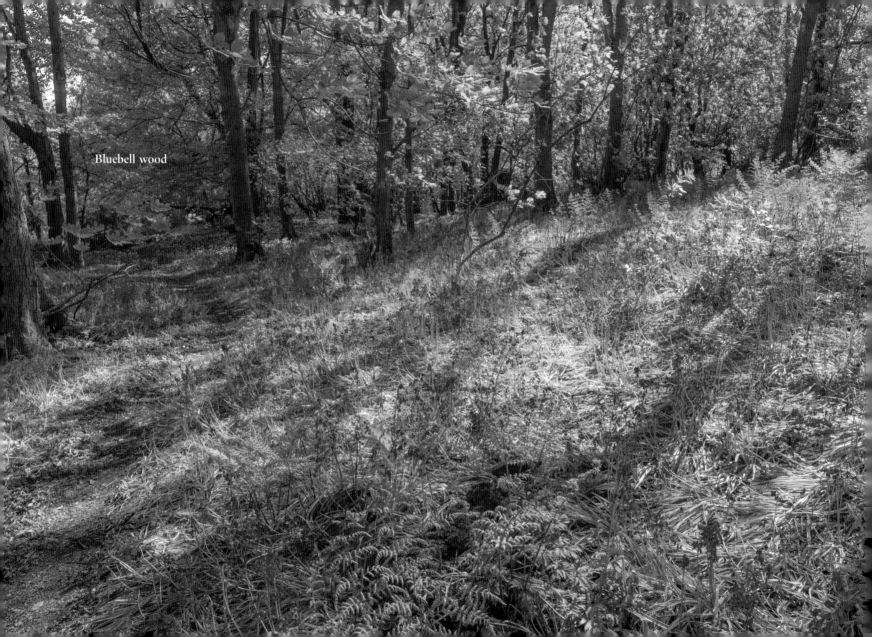

Bluebell wood

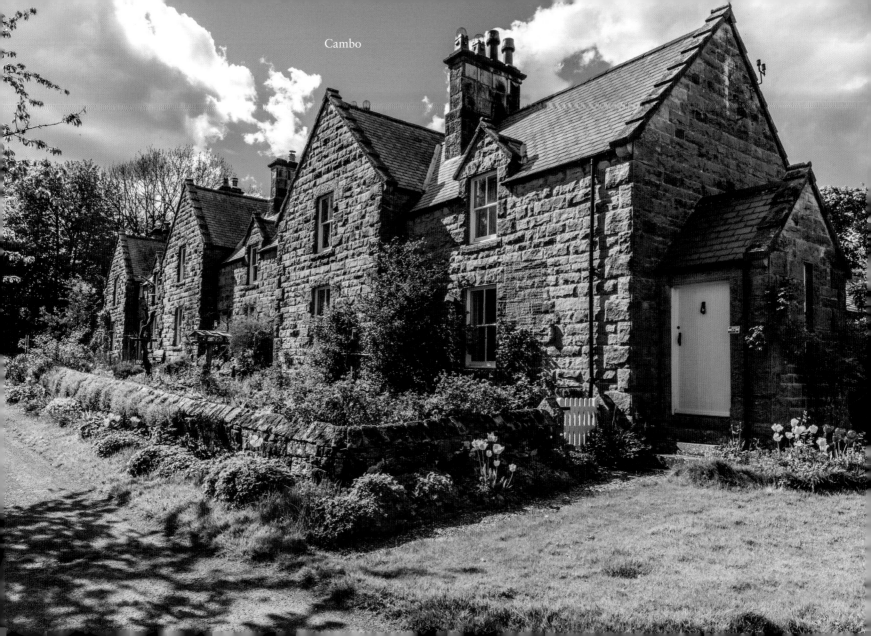
Cambo

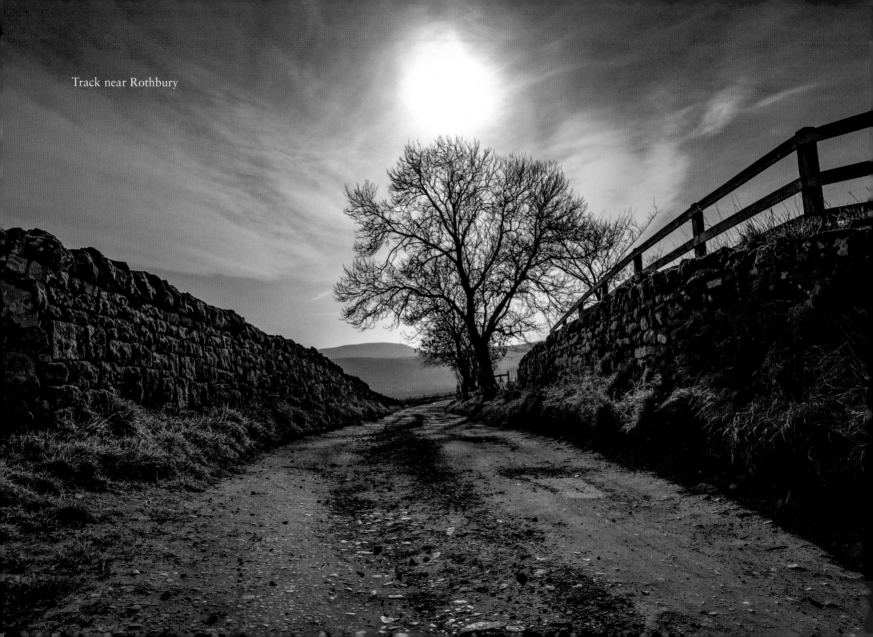

Track near Rothbury

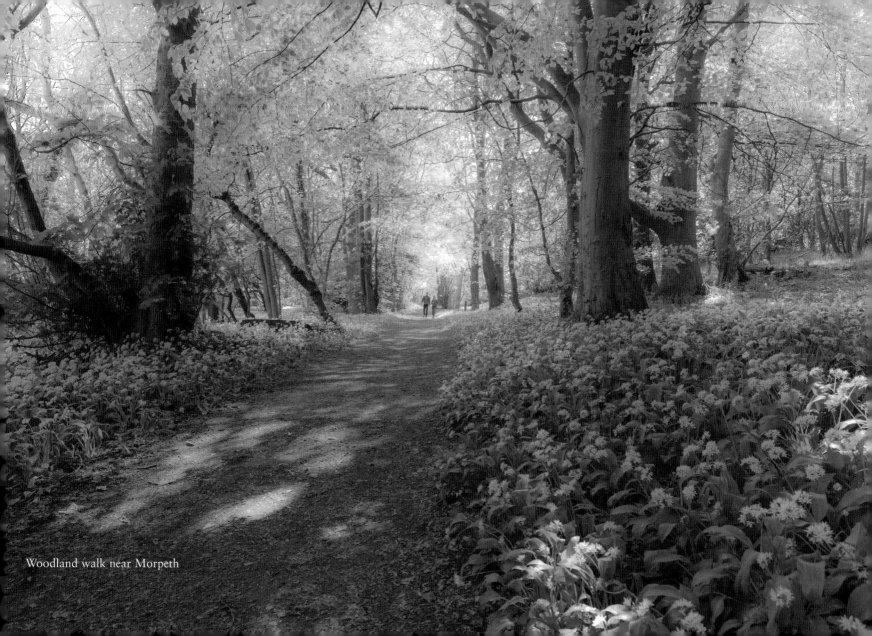
Woodland walk near Morpeth

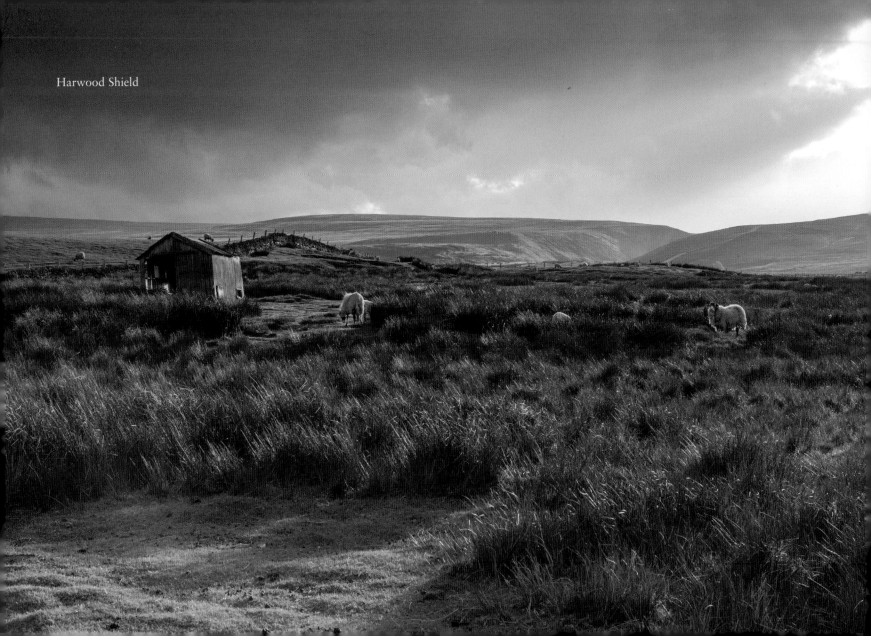

Harwood Shield

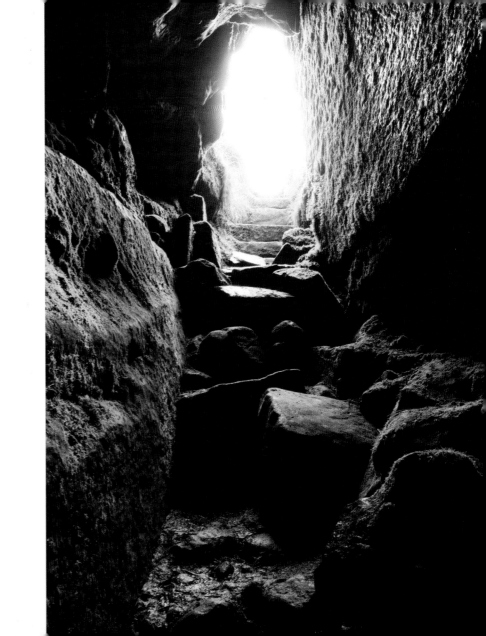

Cateran Hole

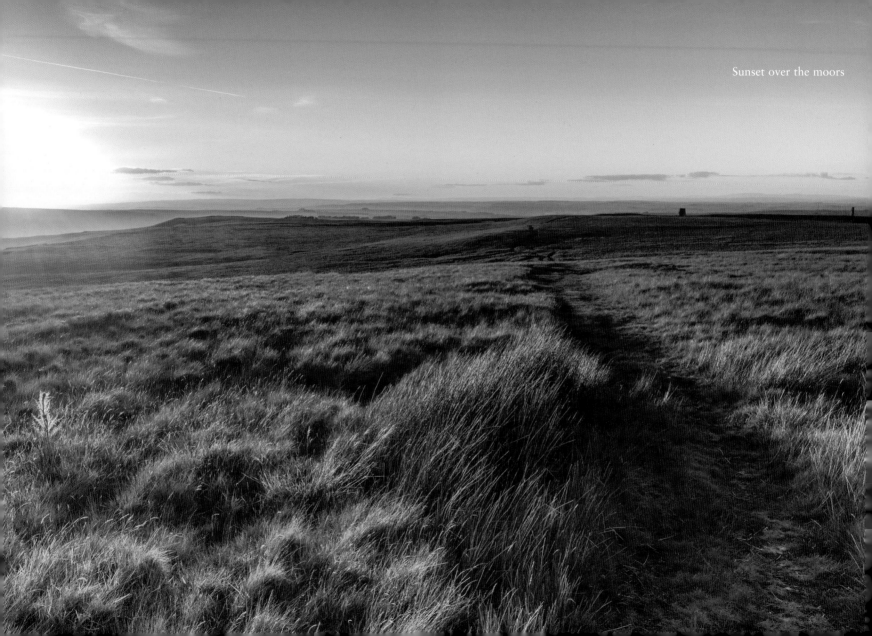
Sunset over the moors

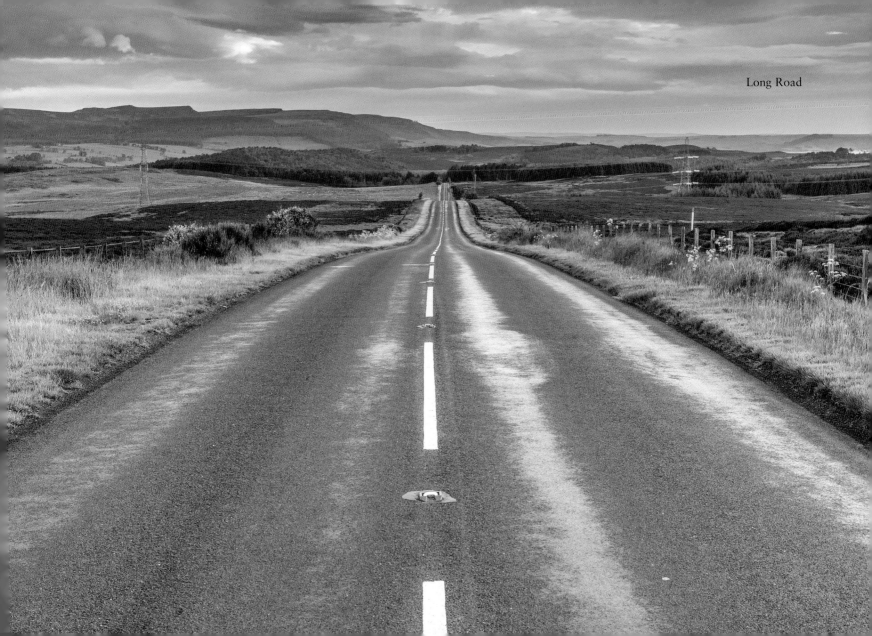

Long Road

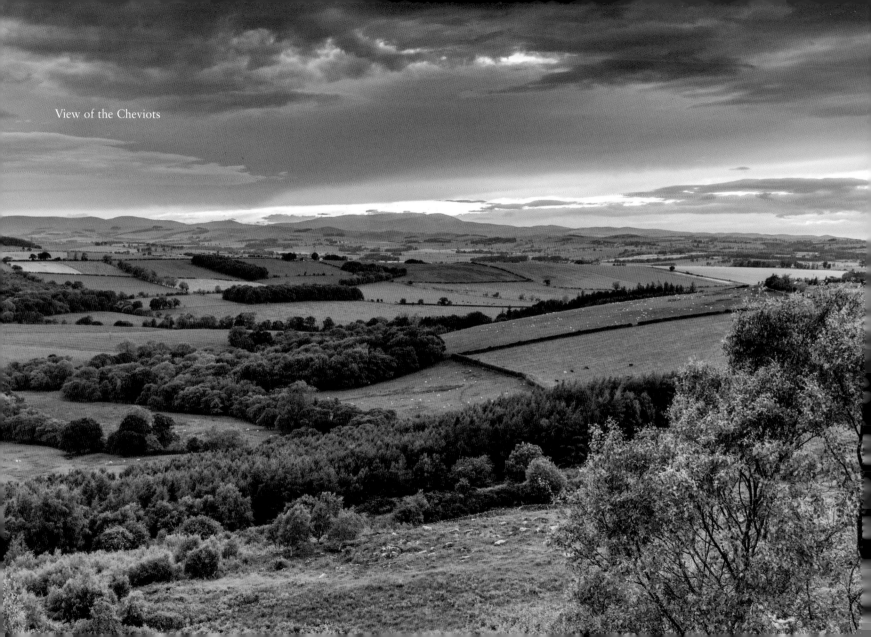
View of the Cheviots

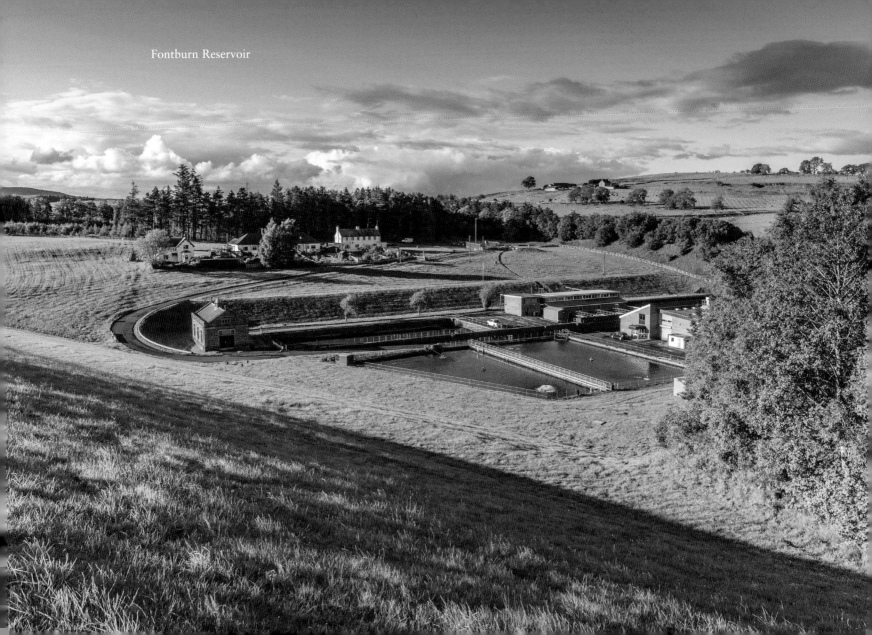

Fontburn Reservoir

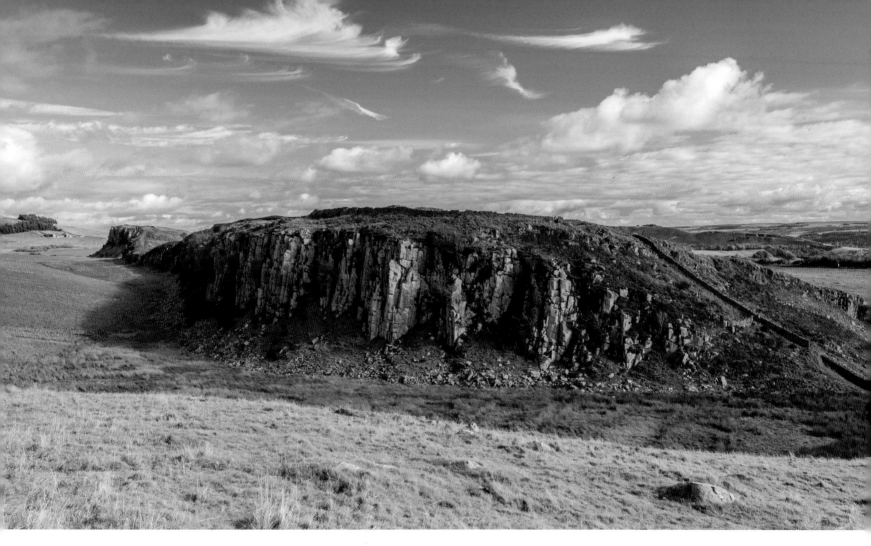

Peel Crags

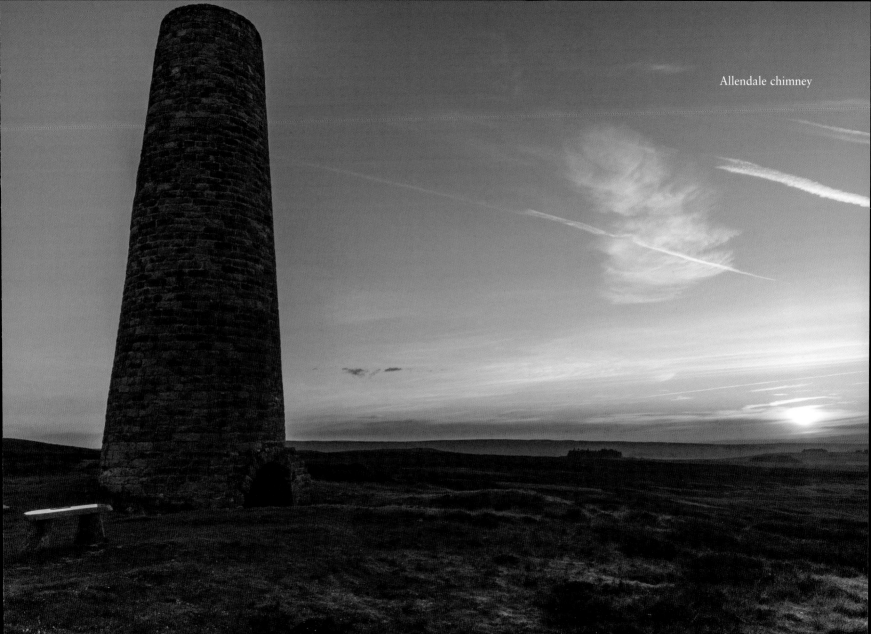
Allendale chimney

RIVERS, STREAMS AND WATERFALLS

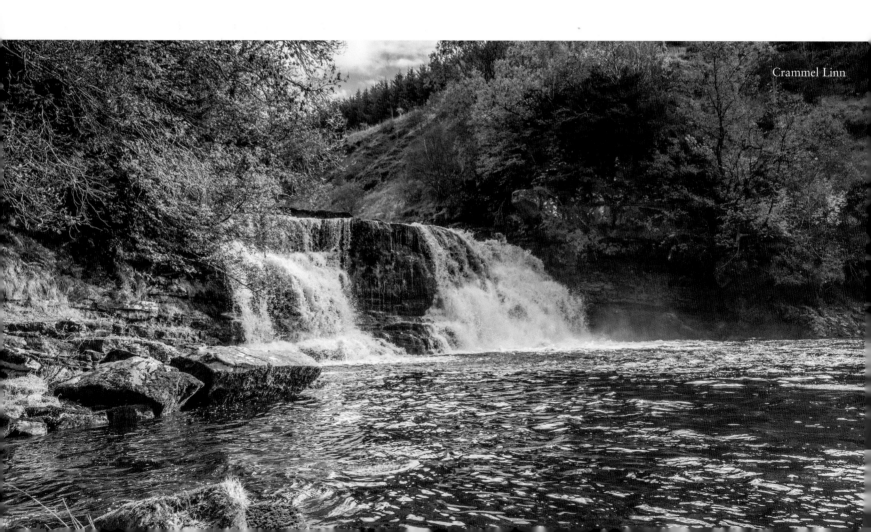

Crammel Linn

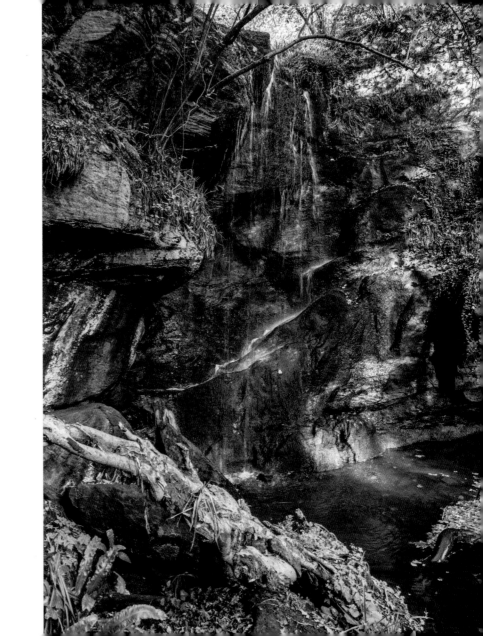

Routin Lynn

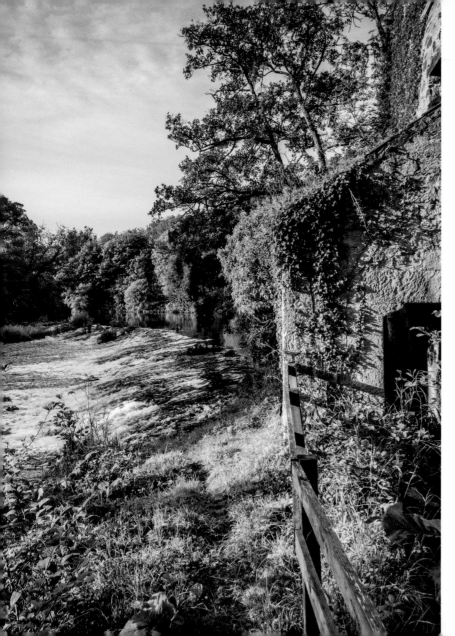

Guyzance Weir

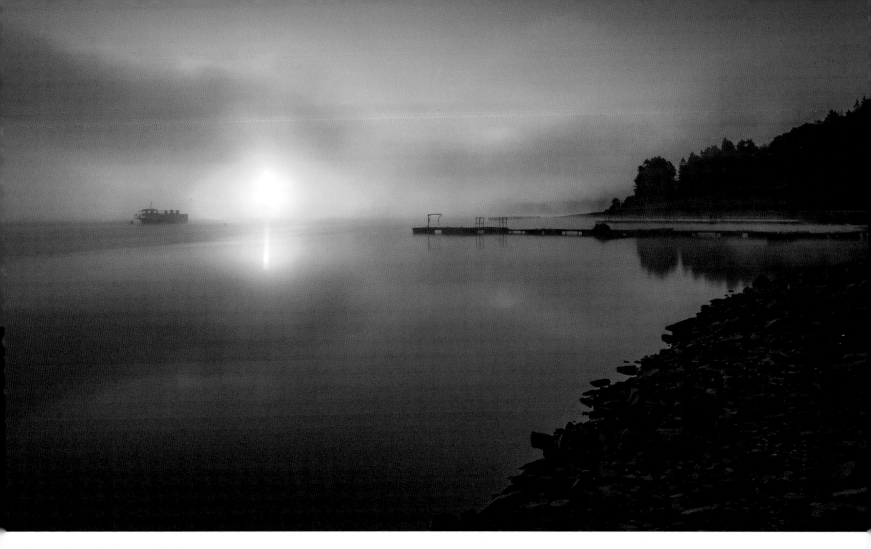

Sunrise through the mist, Kielder

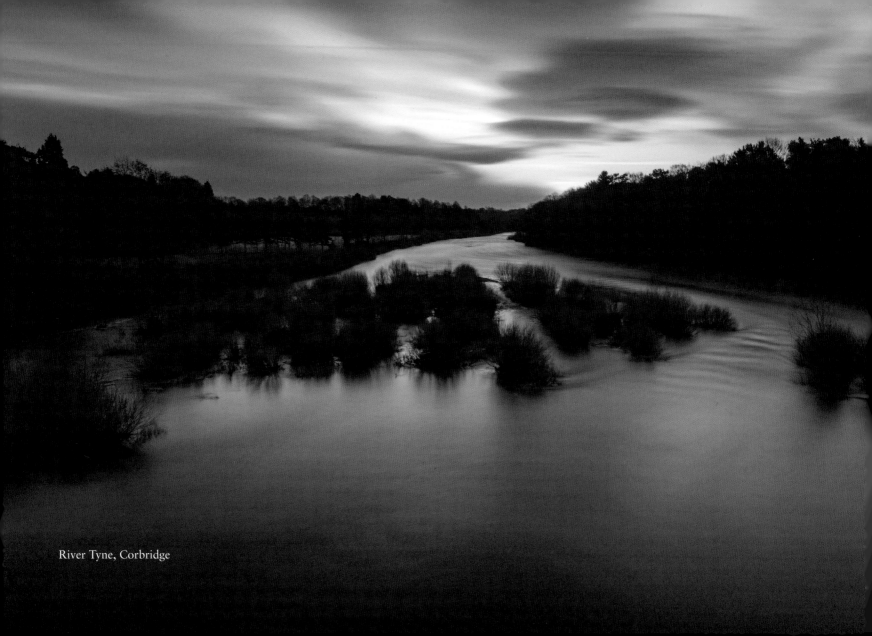

River Tyne, Corbridge

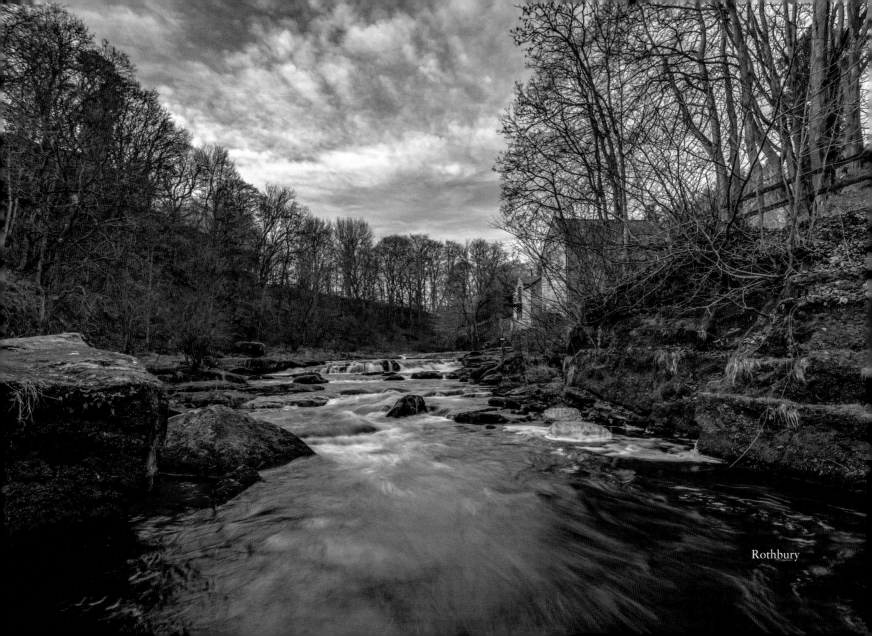

Rothbury

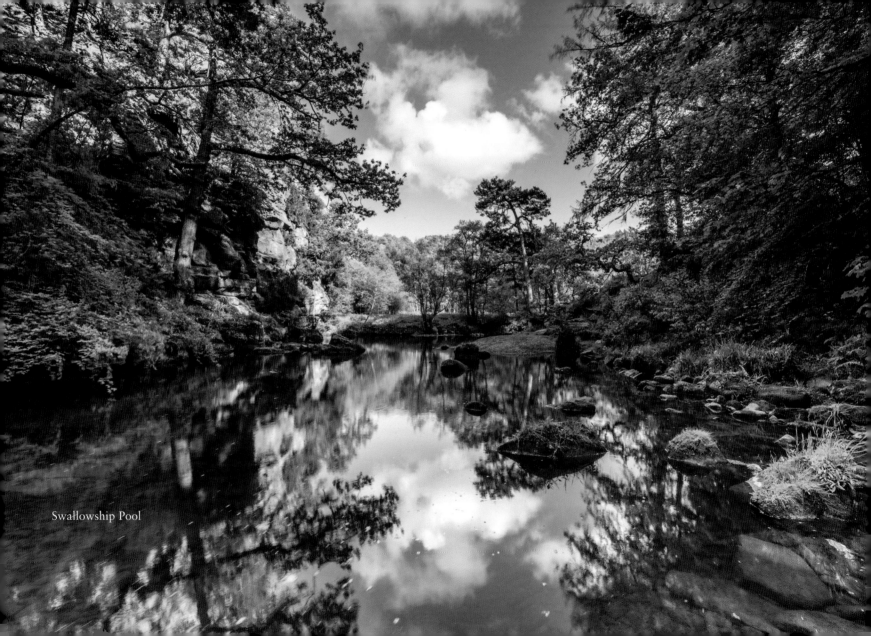

Swallowship Pool

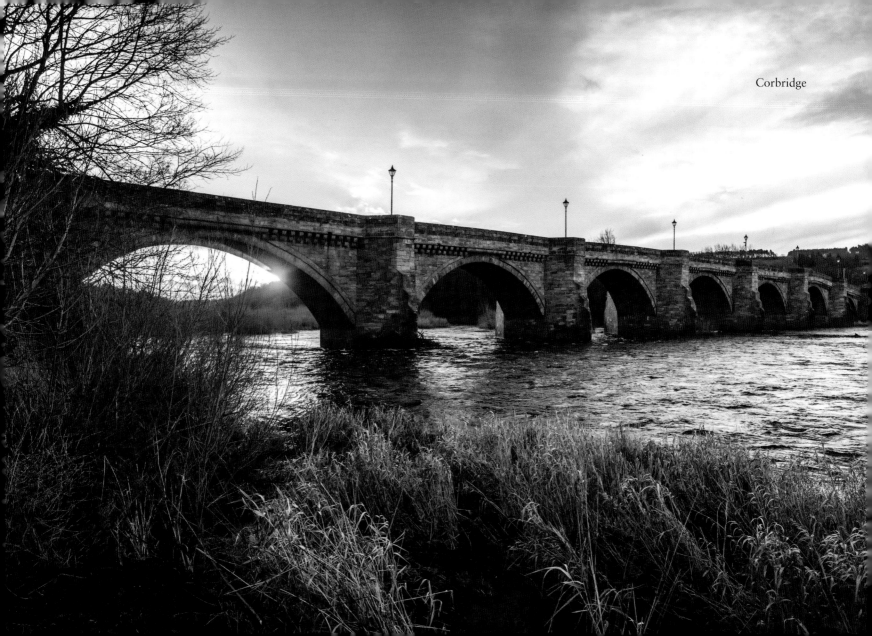

Corbridge

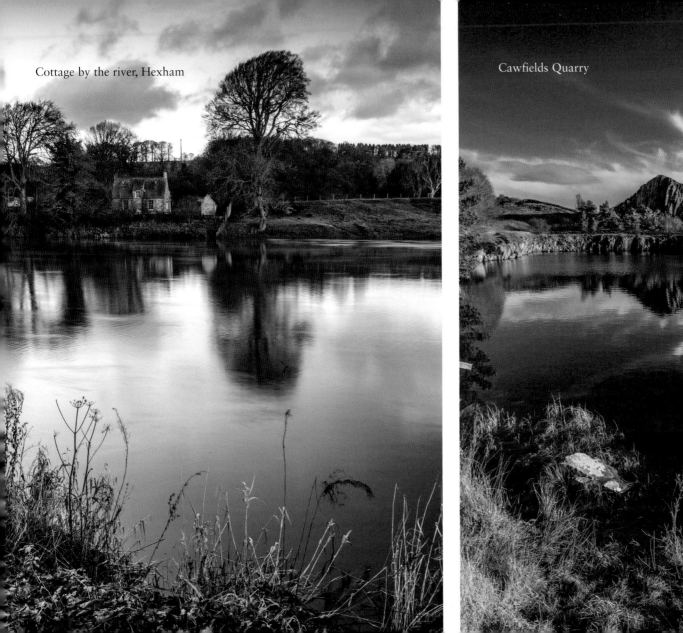

Cottage by the river, Hexham

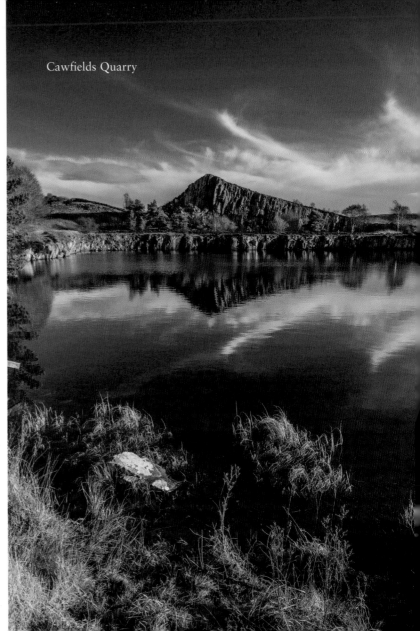

Cawfields Quarry

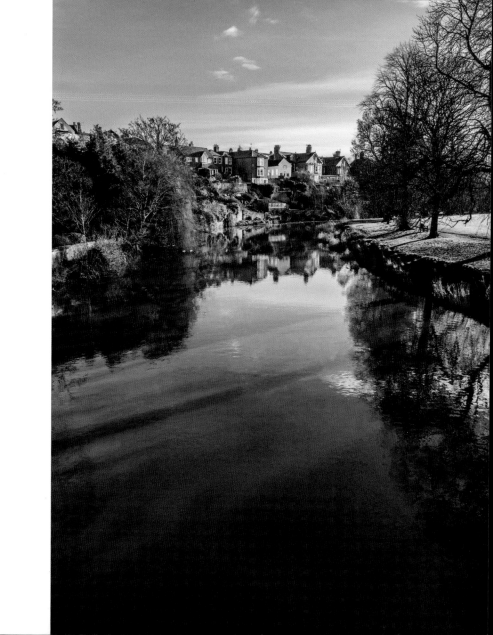

River Wansbeck, Morpeth

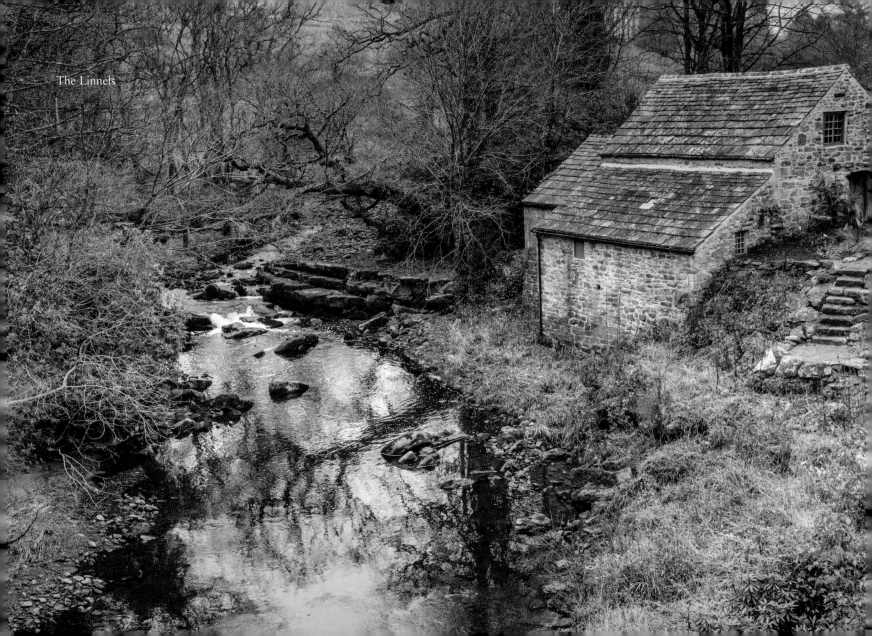

The Linnels

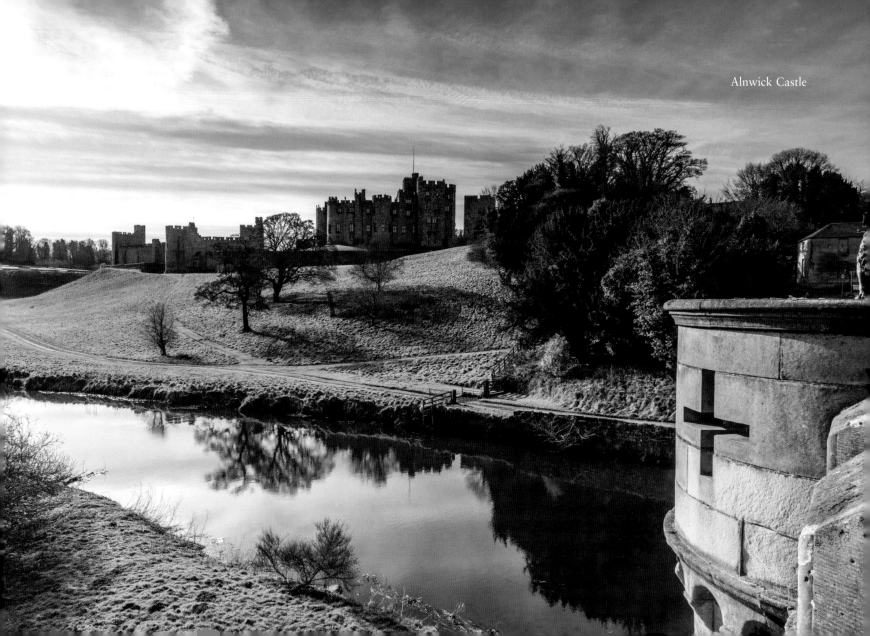
Alnwick Castle

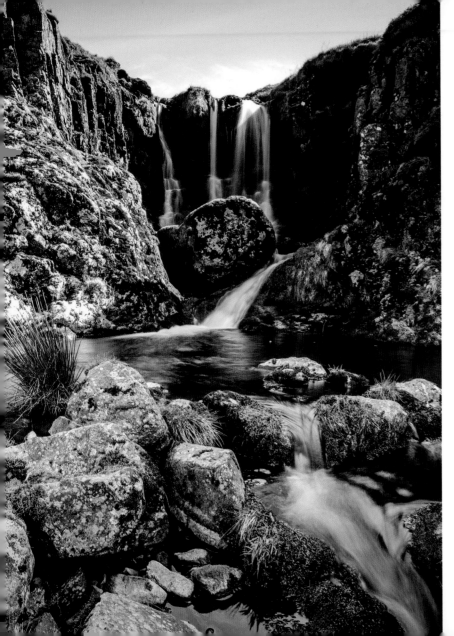

Three Sisters

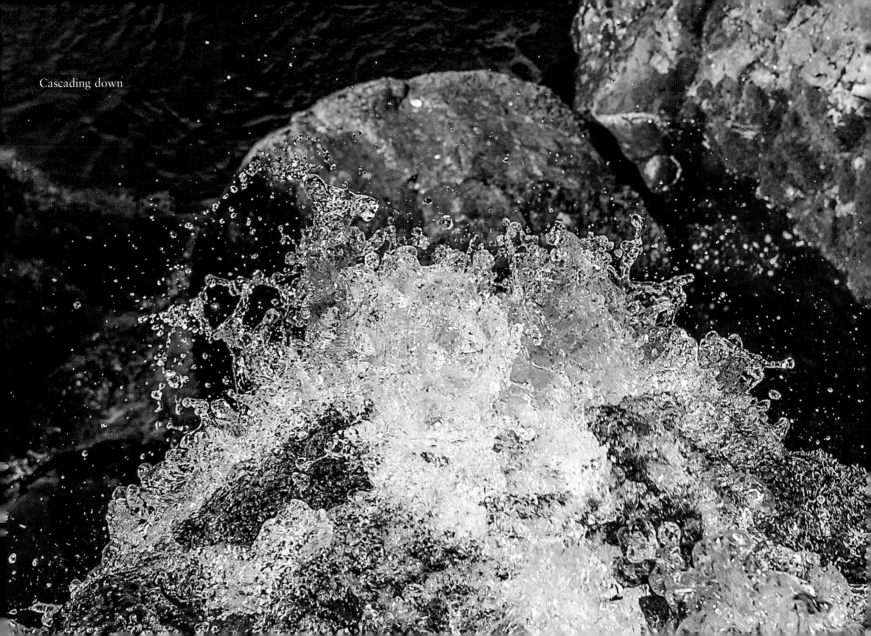

Cascading down

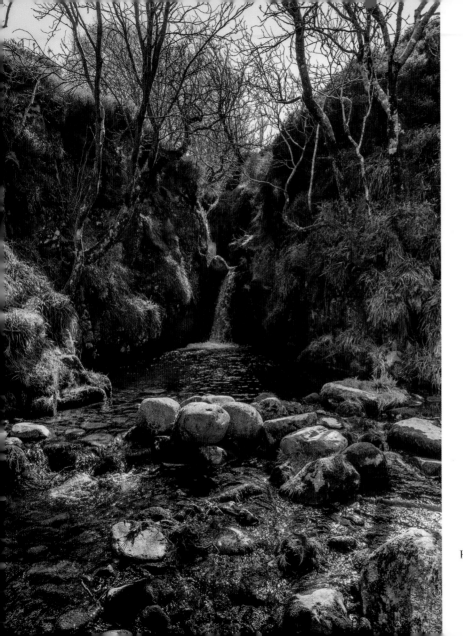

Harthope Linn

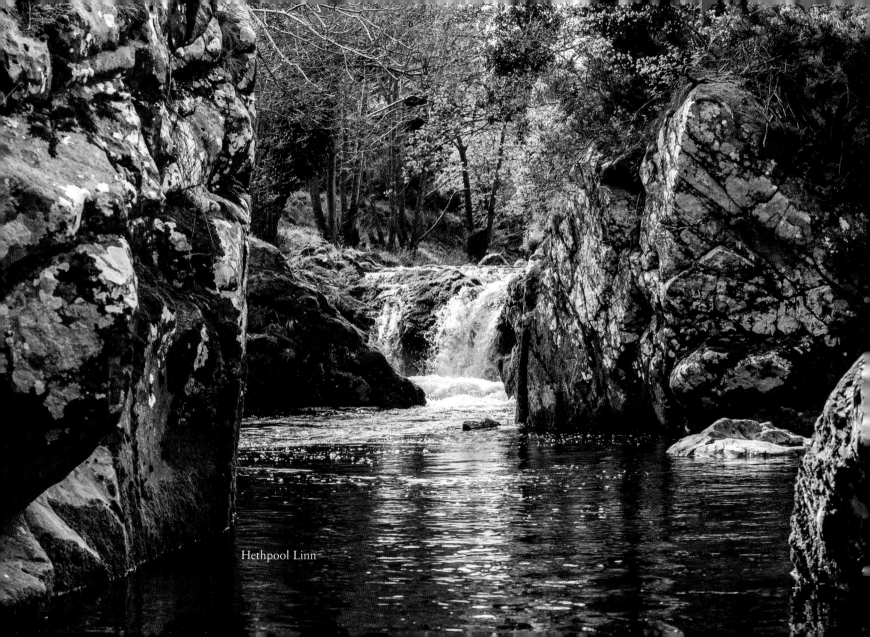

Hethpool Linn

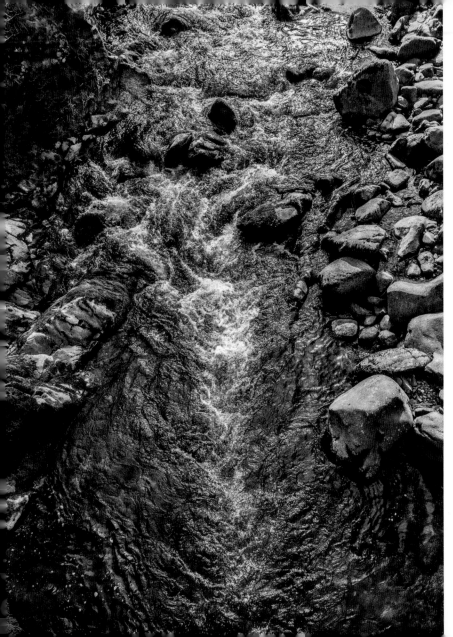

College Burn

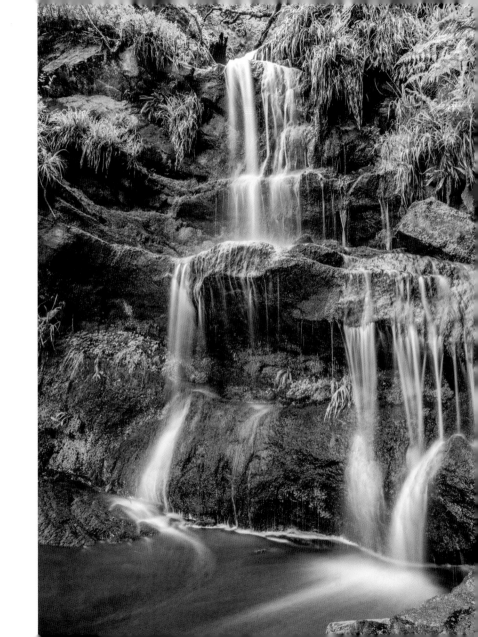

Corby Letch

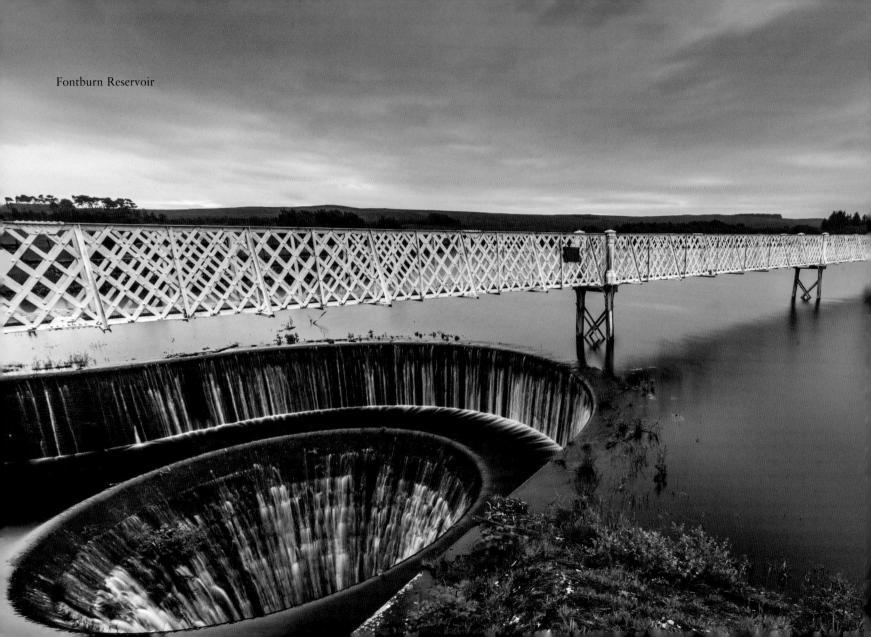

Fontburn Reservoir

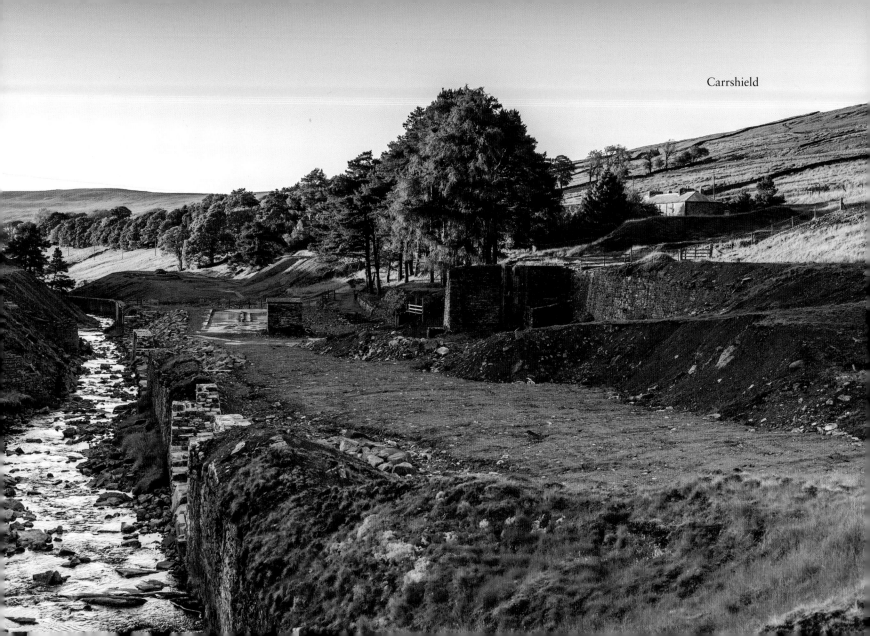

Carrshield

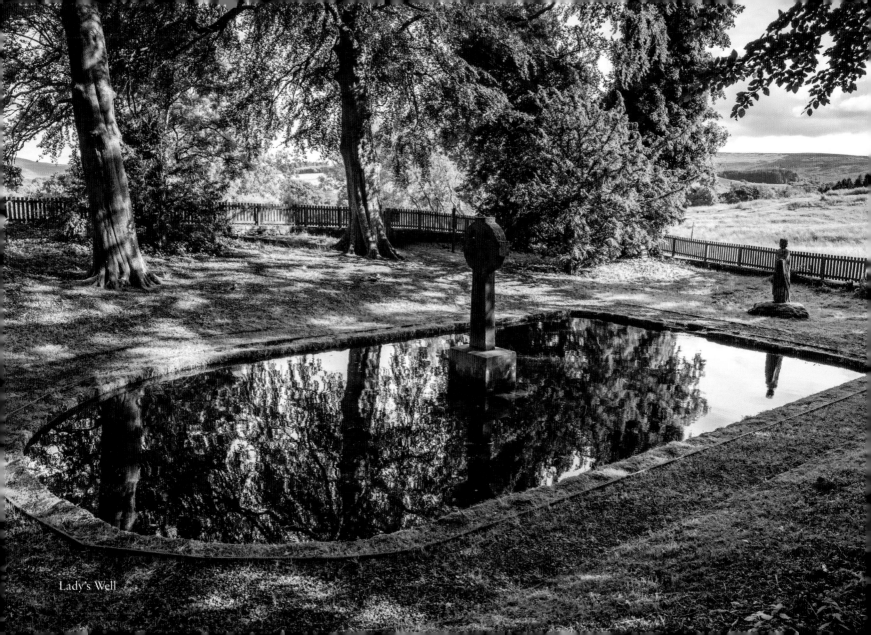

Lady's Well

WILDLIFE

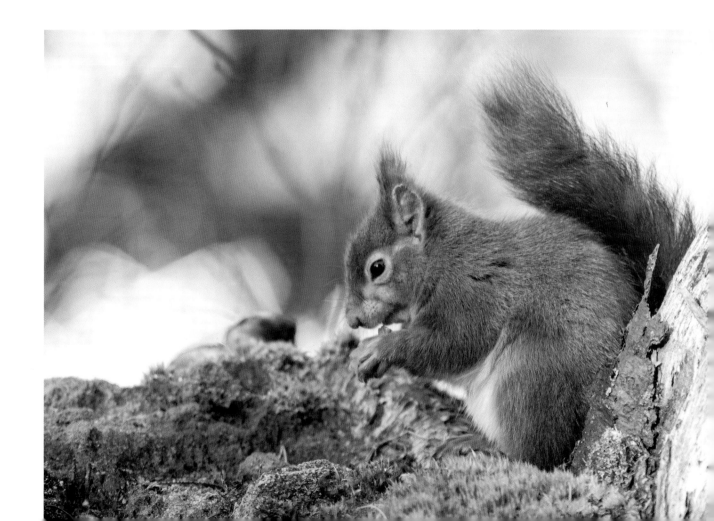

Red squirrel

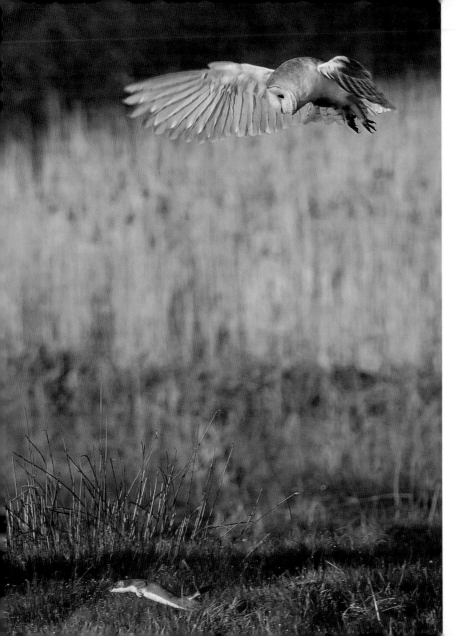

Barn owl and the stoat

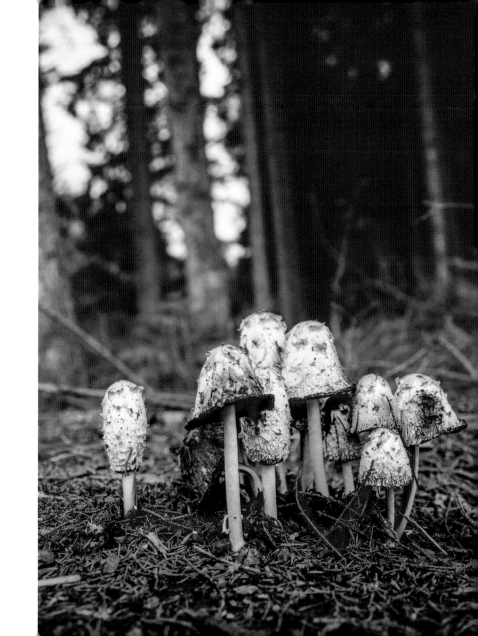

Shaggy ink caps

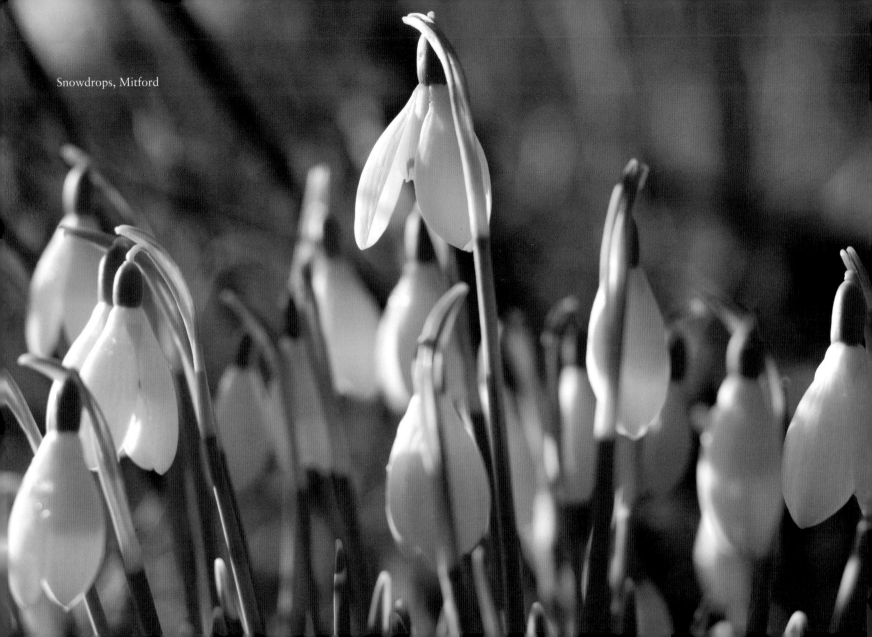

Snowdrops, Mitford

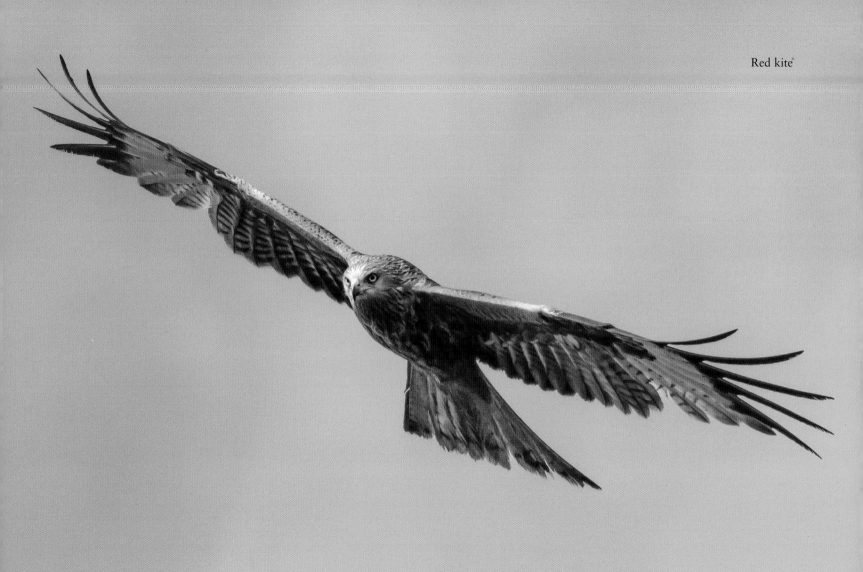

Red kite

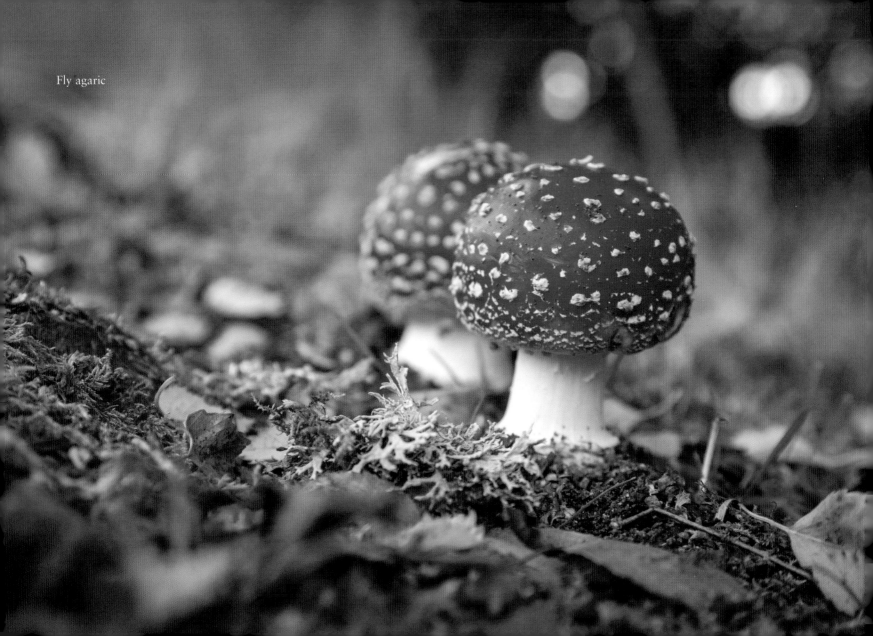

Fly agaric

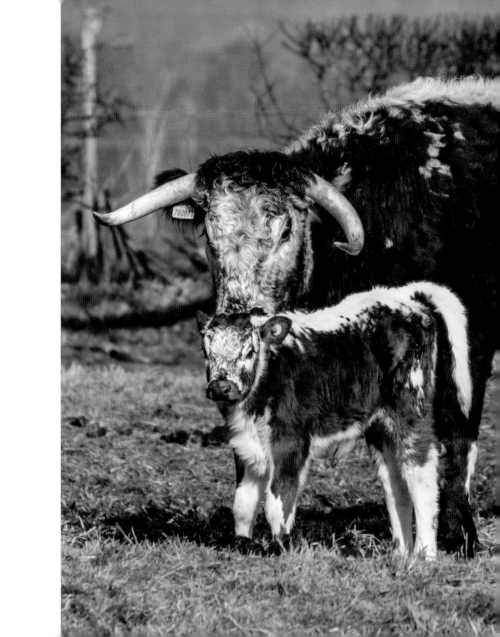

English longhorn and calf, Hexham

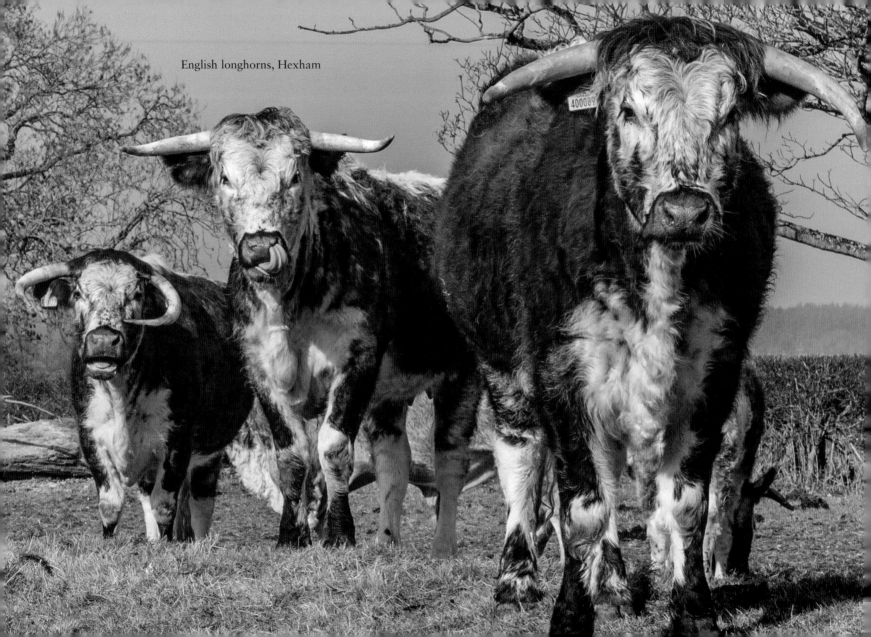
English longhorns, Hexham

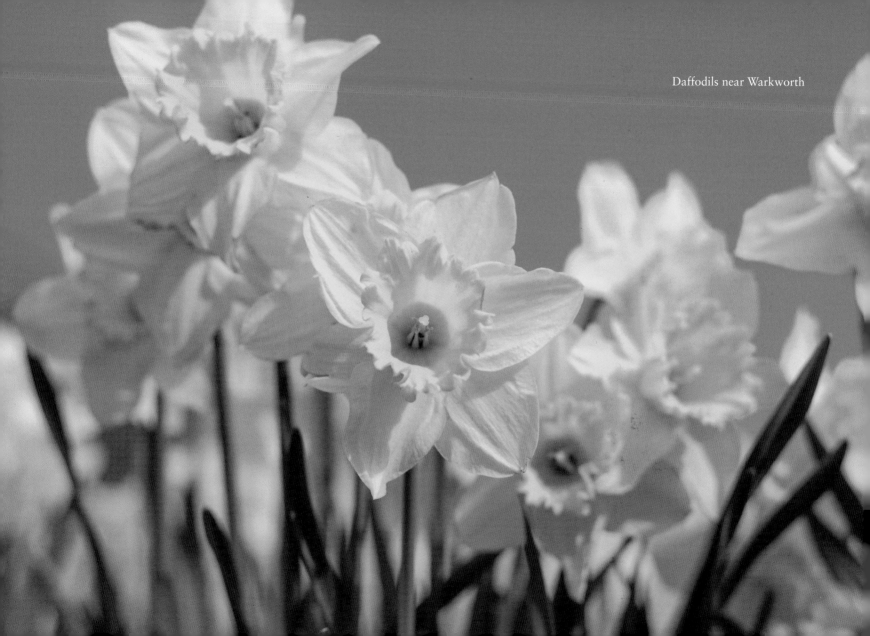

Daffodils near Warkworth

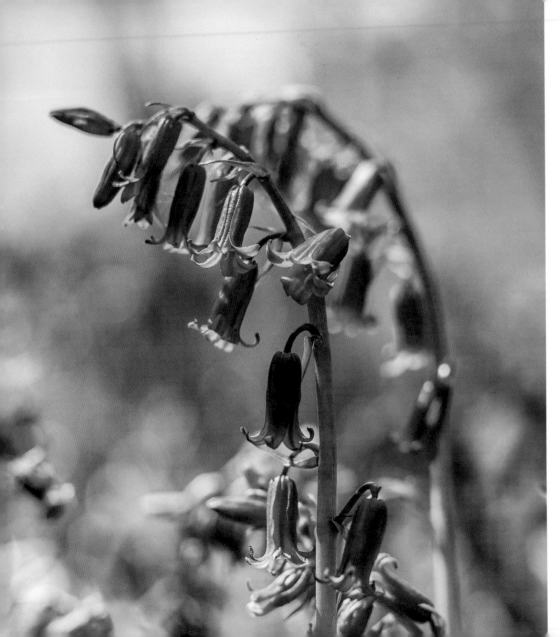

Bluebells near Morpeth

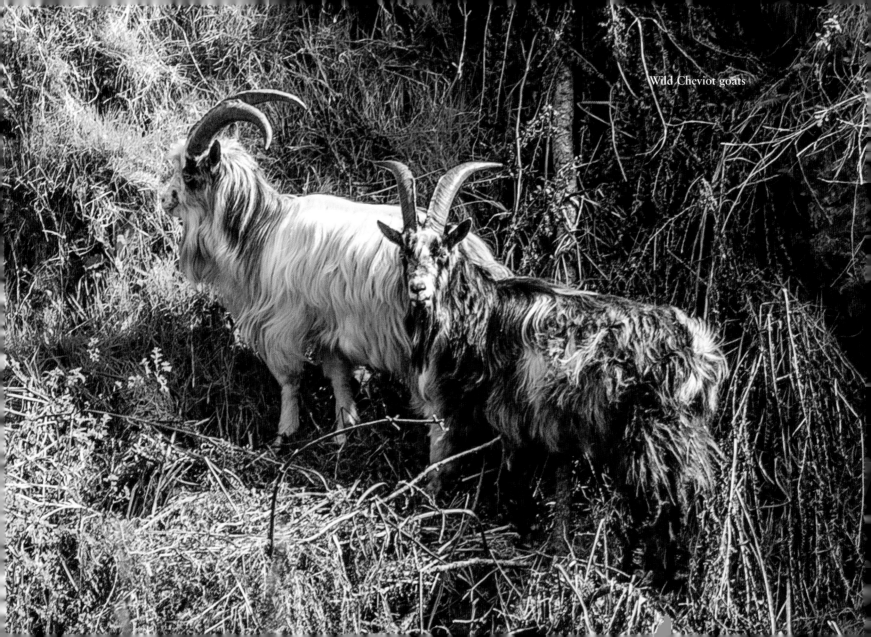
Wild Cheviot goats

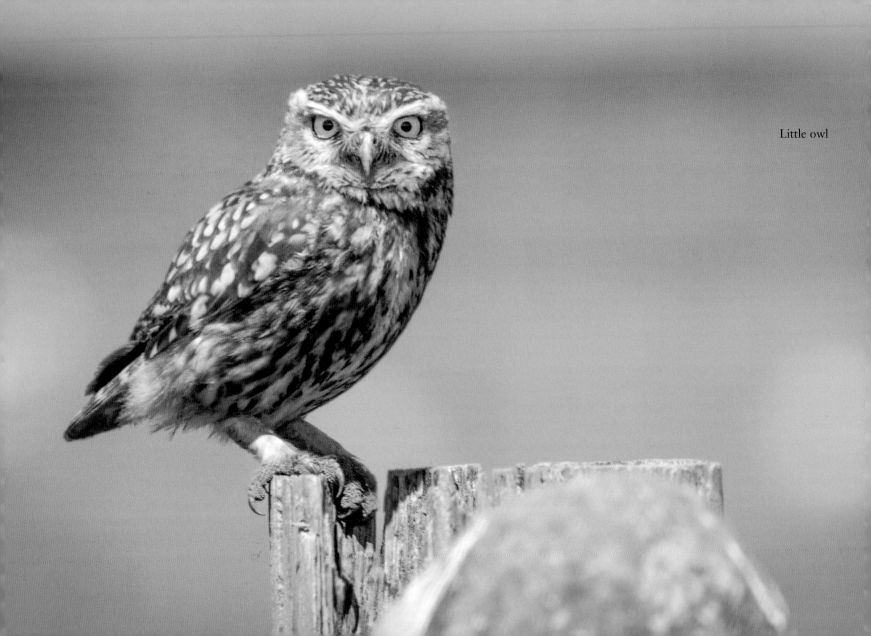

Little owl

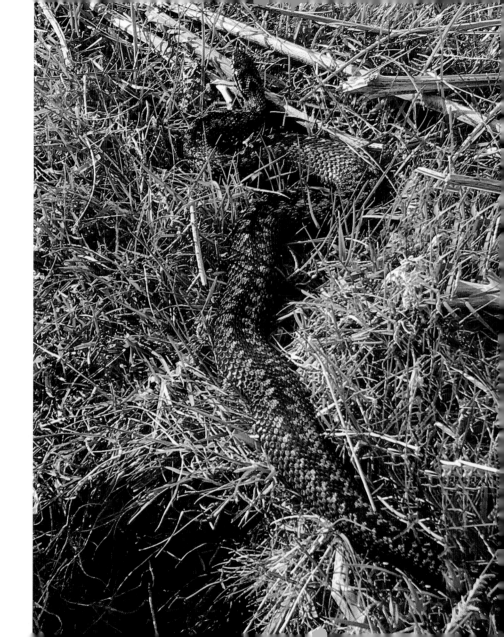

Adder

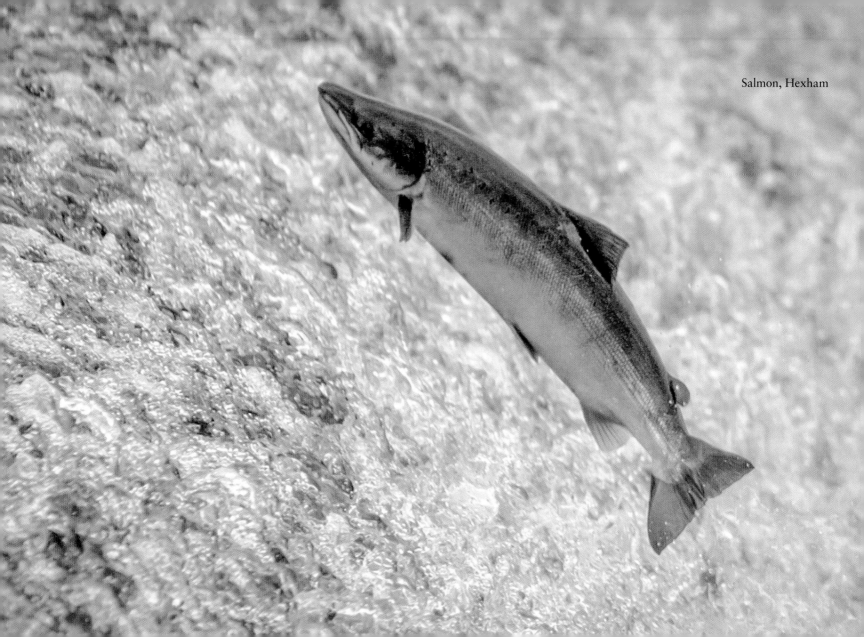

Salmon, Hexham

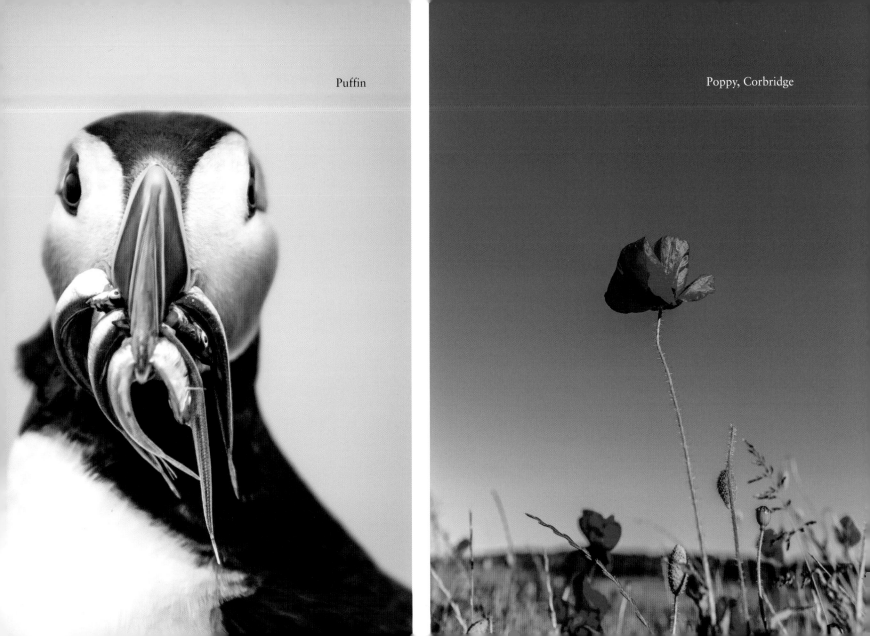

Puffin

Poppy, Corbridge

TOWNS AND VILLAGES

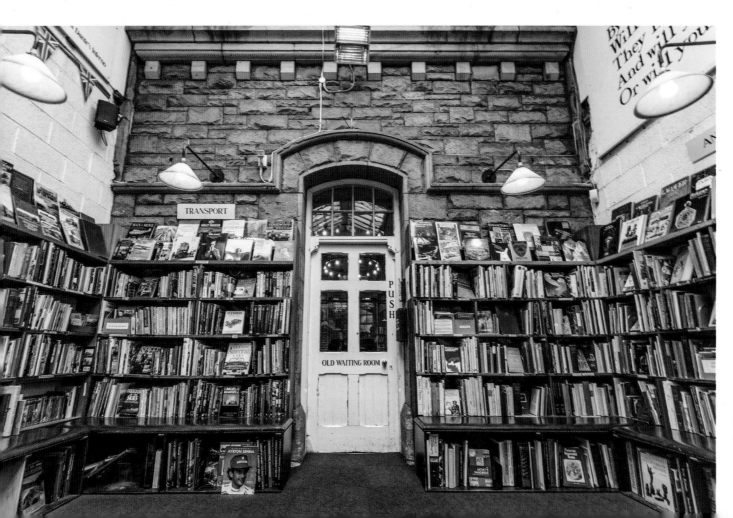

Barter Books,
Alnwick

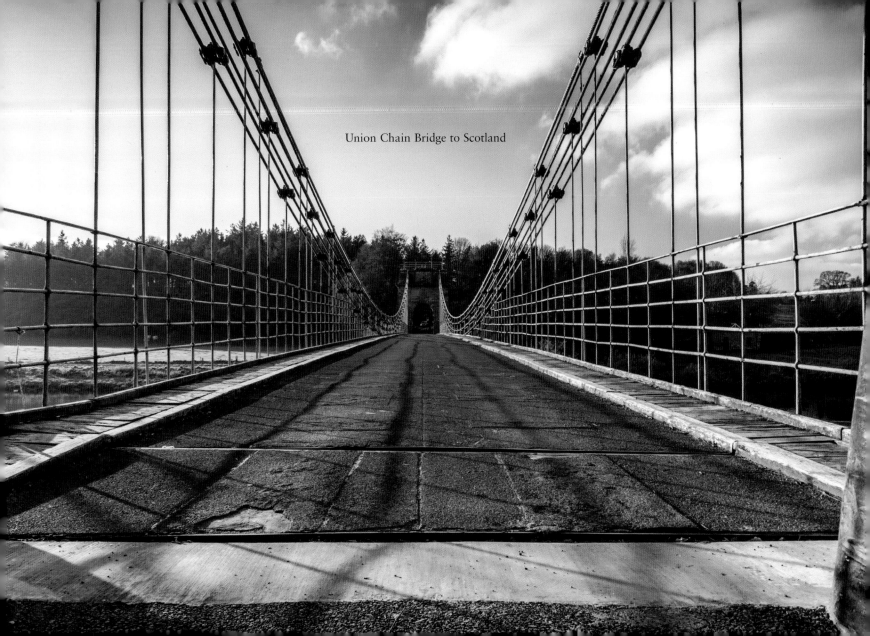

Union Chain Bridge to Scotland

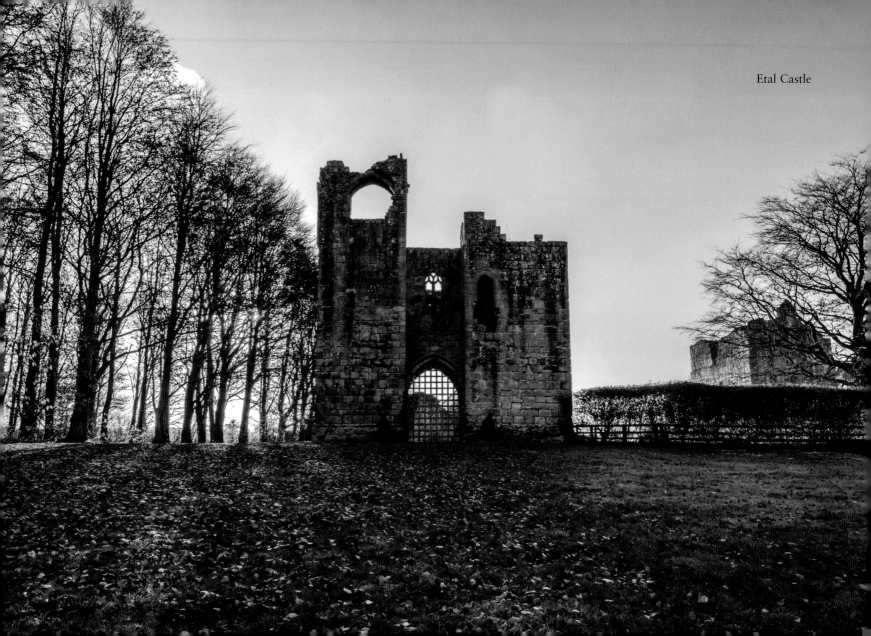

Etal Castle

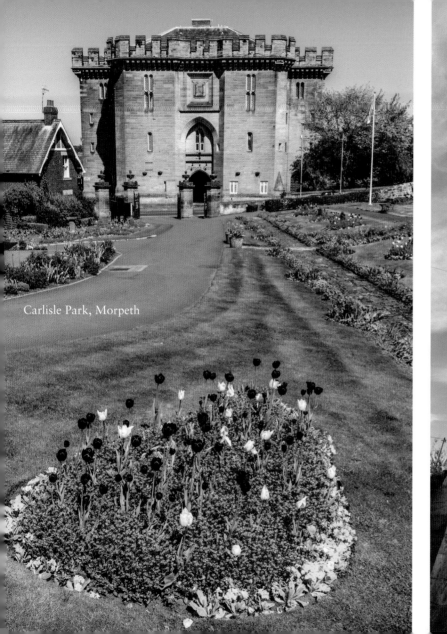

Carlisle Park, Morpeth

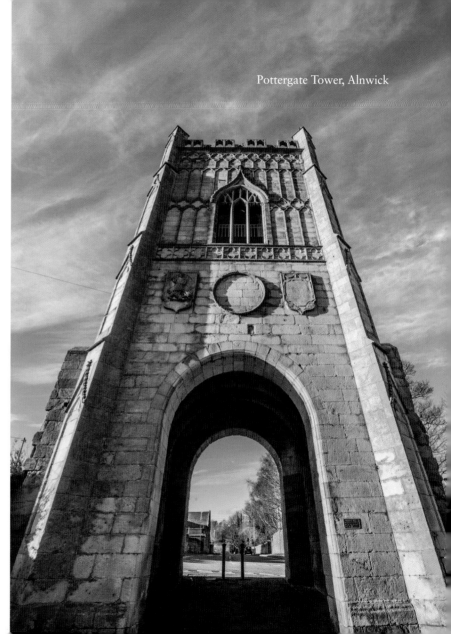

Pottergate Tower, Alnwick

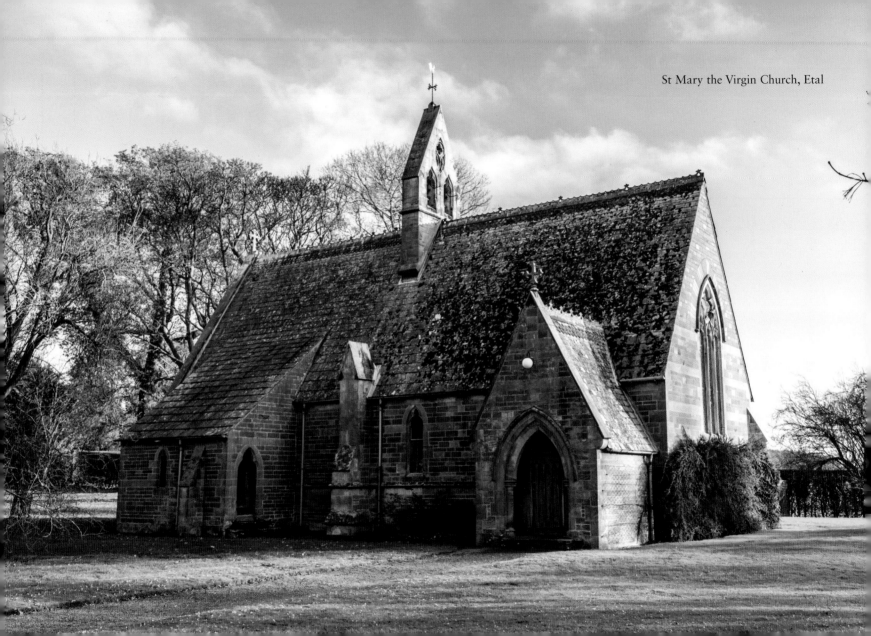

St Mary the Virgin Church, Etal

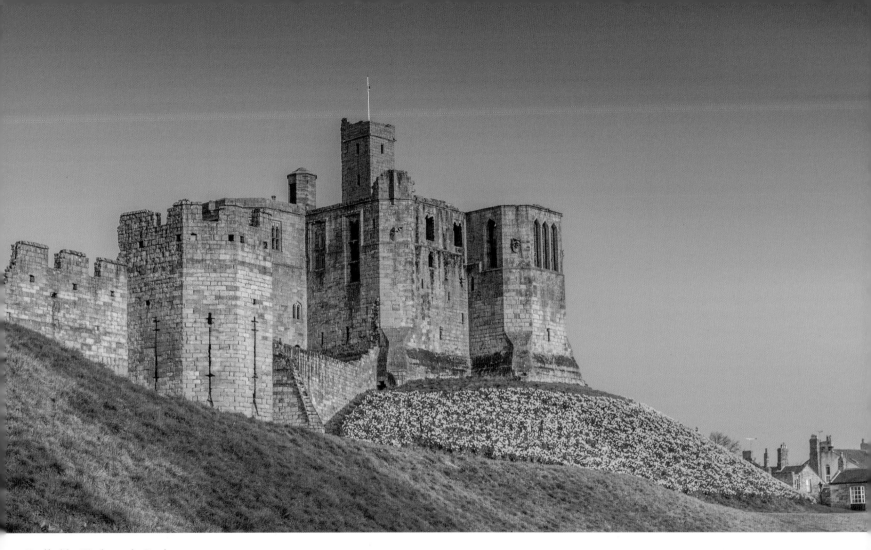

Daffodils, Warkworth Castle

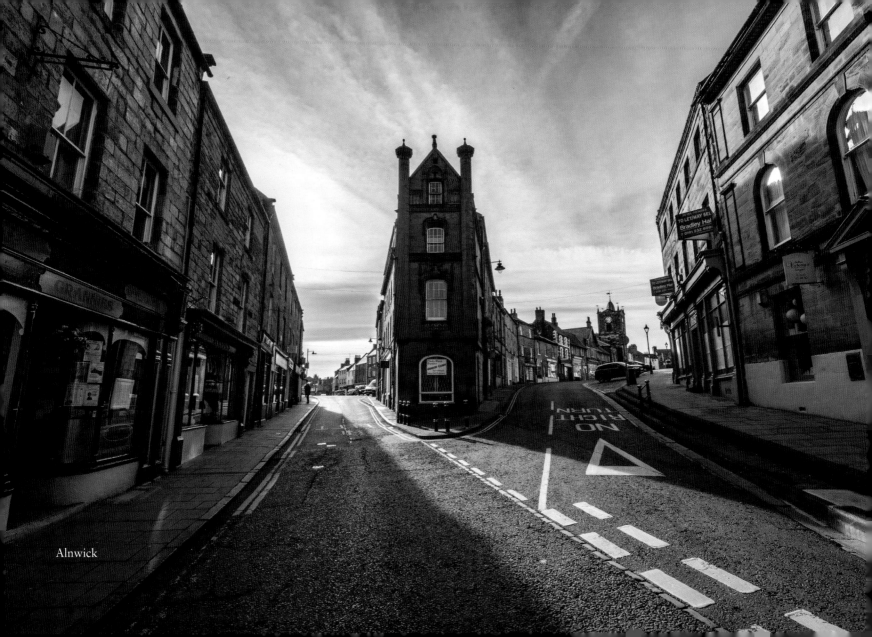

Alnwick

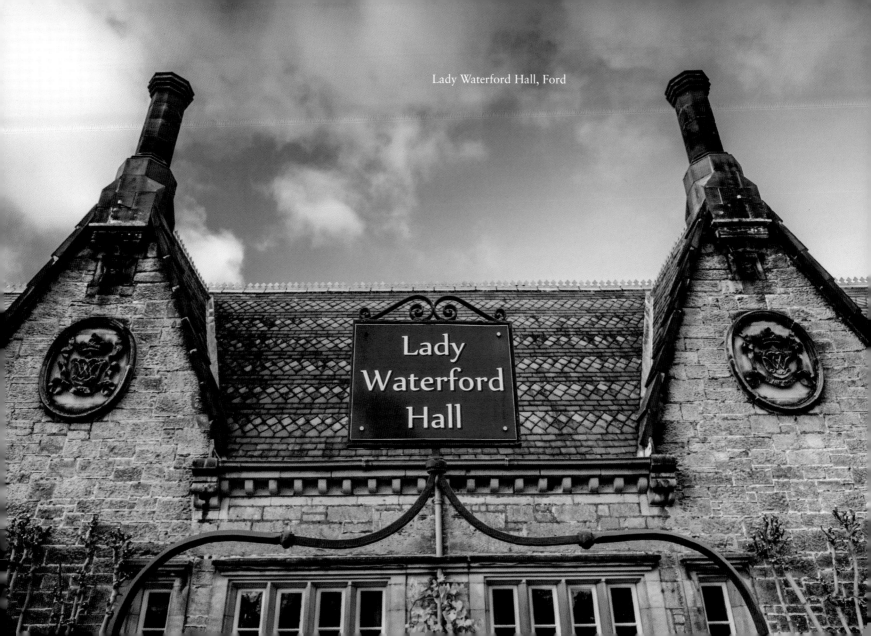

Lady Waterford Hall, Ford

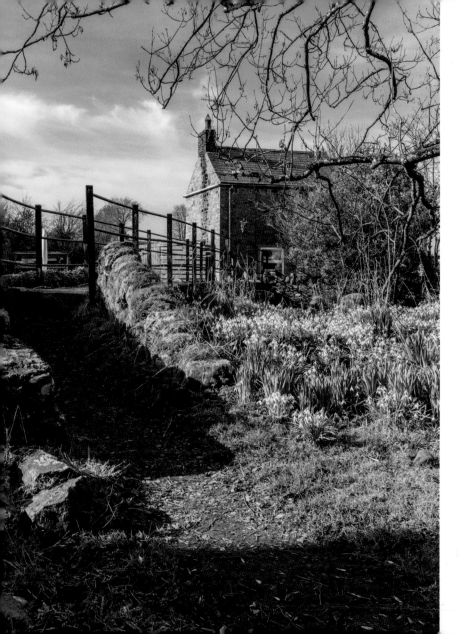

Snowdrops, near Thirlwall Castle

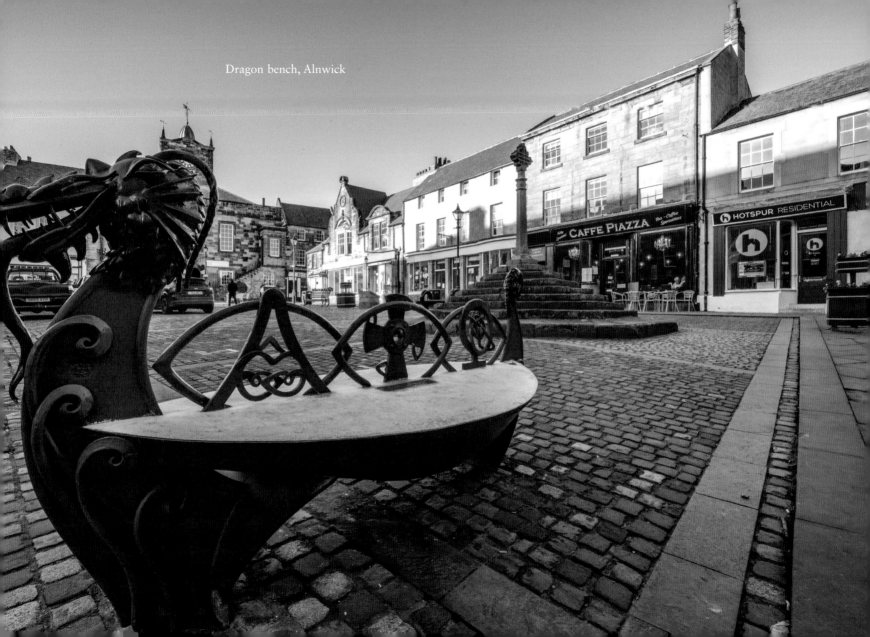

Dragon bench, Alnwick

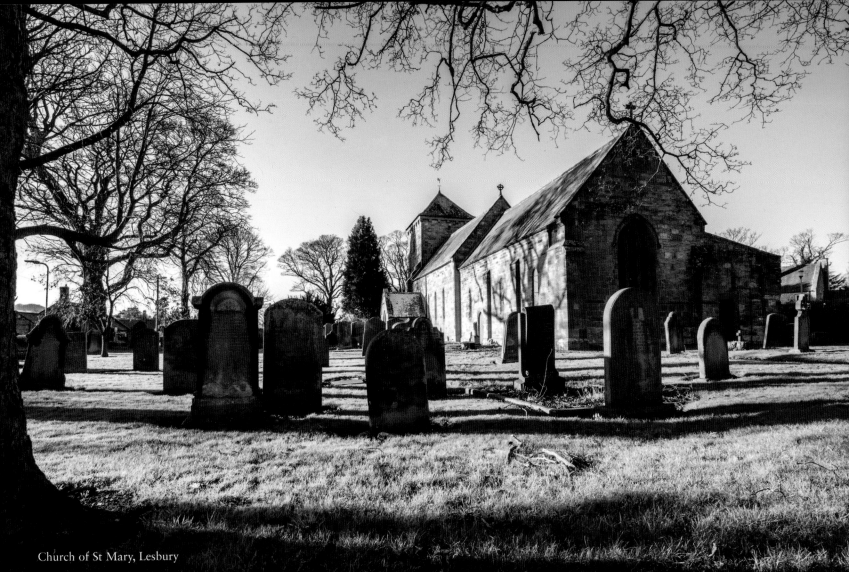

Church of St Mary, Lesbury

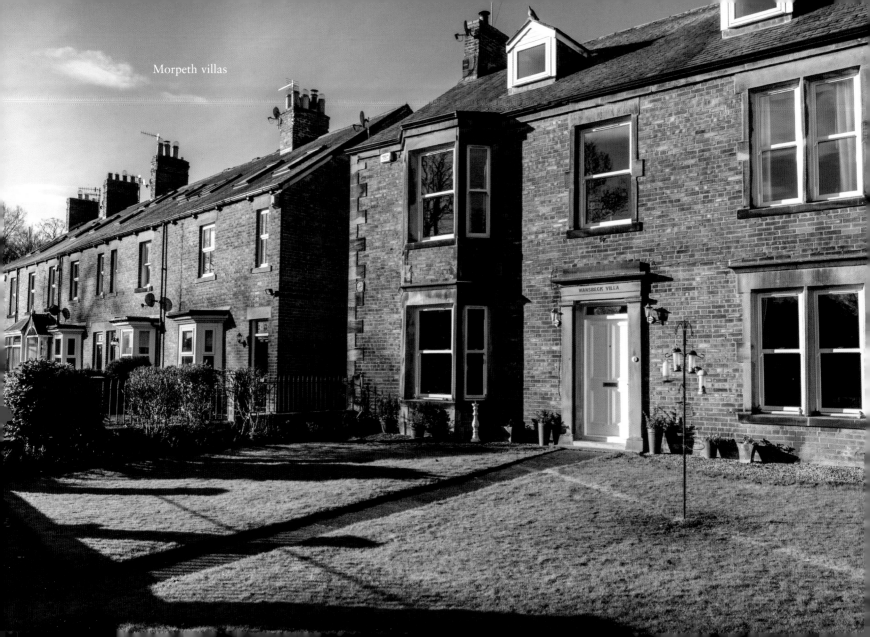
Morpeth villas

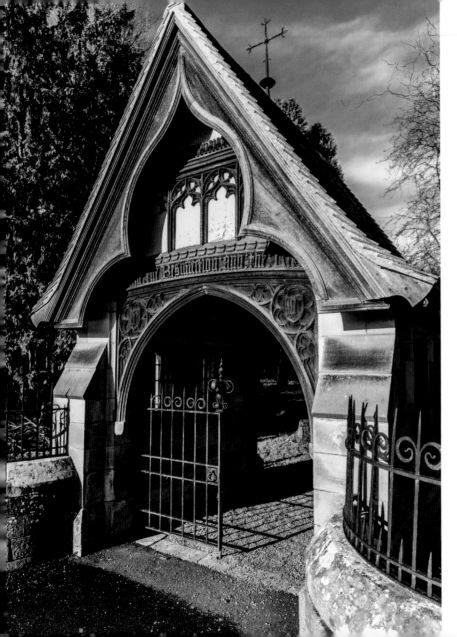

Entrance to St Mary Magdalene's Church, Mitford

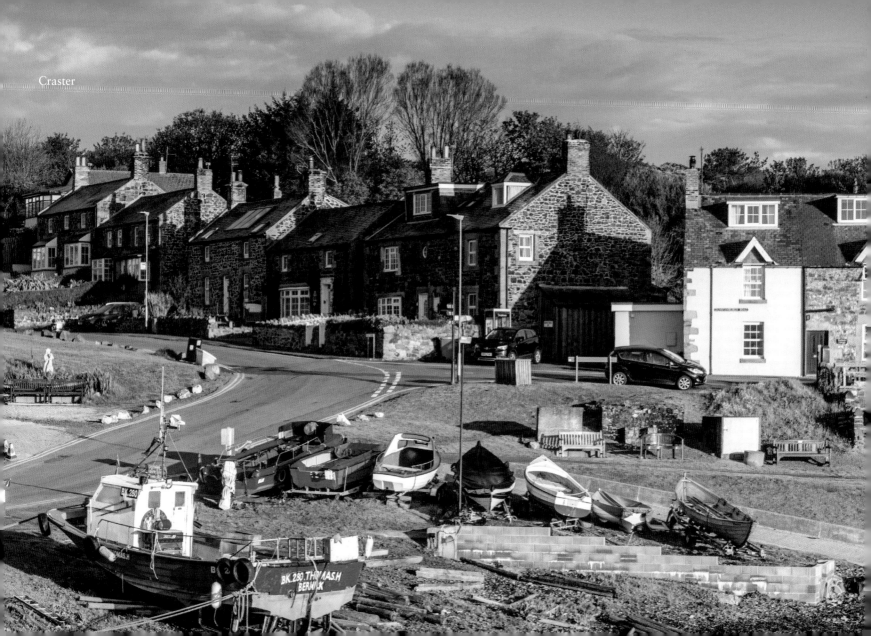

Craster

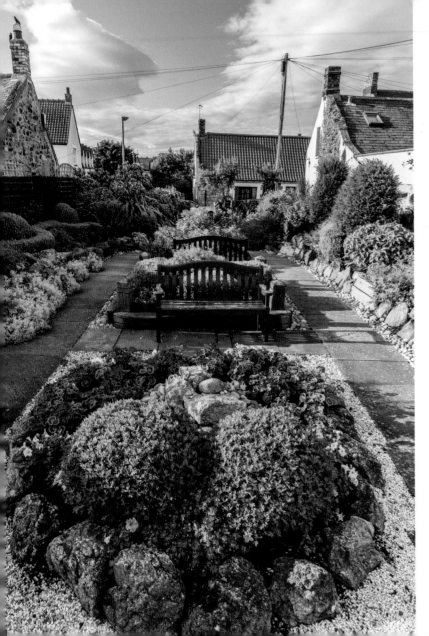

Lindisfarne Gospels Garden